Louis M. Glackens

Louis M. Glackens
Pure Imagination

edited by Ariella Wolens

Louis M. Glackens
Pure Imagination

NSU Art Museum Fort Lauderdale
April 14, 2024 - March 30, 2025
Curated by Ariella Wolens

The exhibition and catalogue is sponsored by The Sansom Foundation, Inc.

Major support for NSU Art Museum Fort Lauderdale is provided by the David and Francie Horvitz Family Foundation Endowment, the City of Fort Lauderdale, Jerry Taylor and Nancy Bryant Foundation, Wayne and Lucretia Weiner, Broward County Cultural Division, the Cultural Council, and the Broward County Board of County Commissioners, Lillian S. Wells Foundation, Community Foundation of Broward, the Wege Foundation, Beaux Arts of Fort Lauderdale, Delia Moog, Dr. Barry and Judy Silverman, Broward Health, Friends of NSU Art Museum, Dr. Mariana Morris, Spirit Charitable Foundation and the Community Foundation of Broward.

Contents

6 **Acknowledgments**
Bonnie Clearwater

10 **Foreword**
Avis Berman

12 **Introduction: Ripped from Yesterday's Headlines!**
Bonnie Clearwater

26 **Born Too Soon: The Life of Louis M. Glackens**
Ariella Wolens

46 **"What Fools These Mortals Be!" Glackens on *Puck***
Richard Samuel West

132 **Exhibition Checklist**

138 **Additional Catalogue Illustrations**

Acknowledgments

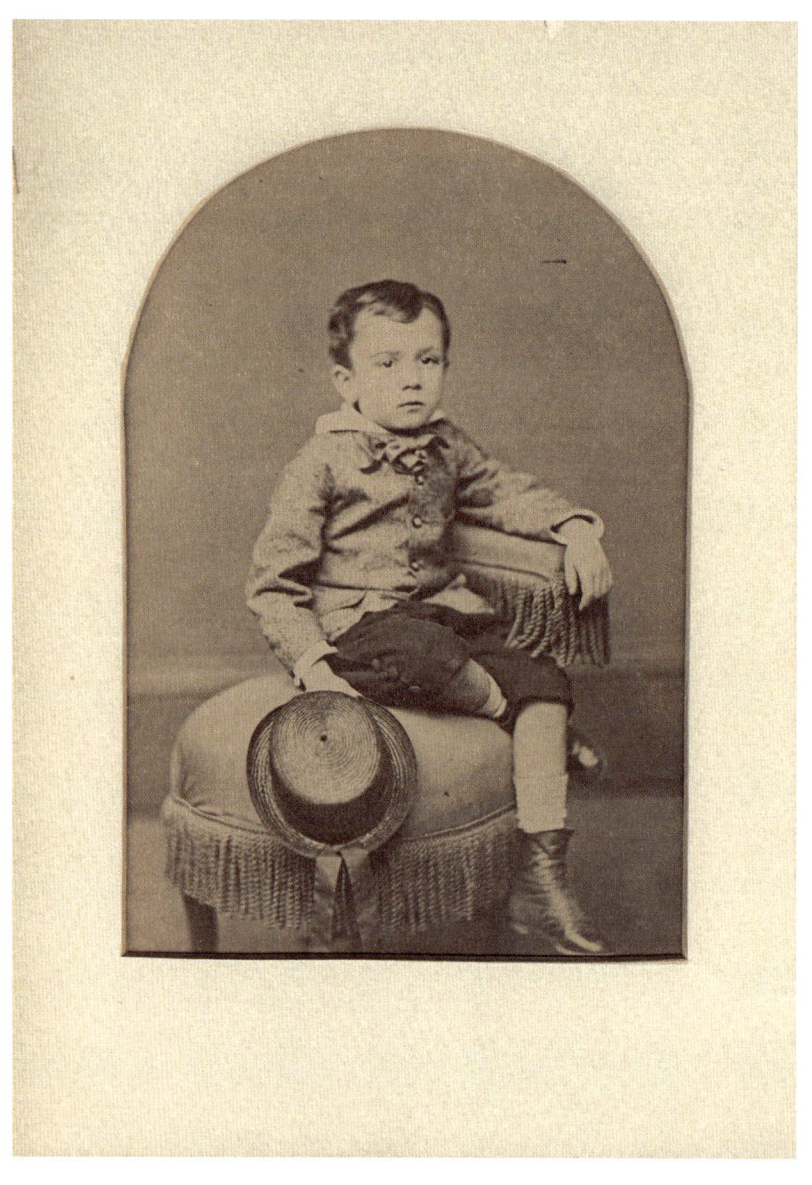

NSU Art Museum Fort Lauderdale is the proud home of the William J. Glackens Collection. This trove of works by one of the leading American artists of the early twentieth century and his circle, along with the extensive archive of photographs, correspondence, and various texts, uniquely positions the Museum as a center of study and research for this key art historical period.[1] The major support that The Sansom Foundation, Inc. has provided over the years has furthered the research into the collection and made it possible to share new discoveries with the public and scholars through exhibitions, publications, and lectures. It is through the support of The Sansom Foundation that the Museum was able to research the work of William's older brother, Louis M. Glackens, and undertake this first solo museum exhibition and monograph showcasing his ingenuity. We extend our deepest appreciation to The Sansom Foundation Board of Trustees: Frank M. Buscaglia, Avis Berman, Richard G. Barrette, and Edward M. Kolesar.

We acknowledge the dedication of Ariella Wolens, the Museum's Bryant-Taylor Curator, for her research and imaginative organization of this important and timely exhibition, and in her role as editor and contributing author. As always, Art Historian Avis Berman has been a fount of knowledge on all Glackens subjects, and we thank her for her enthusiasm for this project and for contributing the foreword to this publication. We are grateful to Richard Samuel West for adding his expertise on American political cartoons to this book with his essay on Louis Glackens' illustrations for *Puck*. Additional thanks go to Skira for publishing this beautiful book.

This exhibition was fundamentally supported by the generous lenders to this exhibition. We thank Delaware Art Museum, Executive Director Molly Giordano, Curator Dr. Heather Campbell Coyle, Erin Tohill Robin, Head Registrar, and Associate Registrar, Meg Thomas, for their essential loans. Our gratitude extends to The Ohio State University Billy Ireland Cartoon Library & Museum's Curator and Associate Professor Dr. Jenny Robb, and Wendy Pflug, Associate Curator of Collections. We acknowledge the support of the G. William Jones Film & Video Collection at Southern Methodist University, notably Hamon Arts Library Director Jolene de Verges

Fig. 1 Photographer unknown
Portrait of Louis Glackens, c. 1871
Cabinet card
5.6 × 4.1 in. (14.2 × 10.5 cm)
NSU Art Museum Fort Lauderdale;
William Glackens Archives
Collection, ARC2021.287

and Curators Scott Martin and Jeremy Spracklen. A special note of appreciation goes to the George Eastman Museum, to Alice Wynd, Alma Omerhodzic and their film preservation team, who worked with us to digitize and restore Glackens' 1918 film, *Our Bone Relatives*, on the occasion of this exhibition. We thank Richard Samuel West, and William Chrisant of The Old Florida Book Shop for their enduring support and expert guidance throughout this project. We are indebted to all these individuals and institutions for their willingness to share the extraordinary collection pieces that have enriched our presentation, providing audiences with the rare opportunity to engage with these works of art.

The Museum's entire staff has contributed enormously to the successful organization and presentation of this exhibition, including the curatorial staff consisting of Exhibition & Curatorial Project Manager Jordyn Newsome, who expertly coordinated the loans, shipping and installation of the exhibition; Senior Registrar Rebecca Vaughn and Registrar Caroline McNabb, who attentively saw to the many artworks and artifacts within the exhibition. I thank Cathie Conn for her judicious proofreading, Oliver Loaiza, Head Preparator and Technician, for coordinating the installation and supervising the art handlers, and Charles Ross for his assistance with design. The Museum's Education staff headed by Lisa Quinn, the Lillian S. Wells Education Curator, along with Michael Belcon, Wege Foundation Assistant Curator, and Tristen Trivett, the Community Engagement & Arts Education Coordinator, together developed compelling educational content and oversaw countless exhibition tours with the Museum's dedicated corps of docents for school groups and adults. Thanks also go to Communications & Public Relations Manager David Guidi for producing media content for this exhibition.

Special thanks go to the Museum's extraordinary Board of Governors, chaired by Michelle Howland Sussman, and to Nova Southeastern University, for their continued and enthusiastic support.

Bonnie Clearwater
Director and Chief Curator
NSU Art Museum Fort Lauderdale

[1] The William J. Glackens Collection is accessible on the Museum's online database, https://collection.nsuartmuseum.org, as well as in-person at the Museum's William J. Glackens Research Center.

Fig. 2 Phillip Edward Chillman
Portrait of Louis Glackens, c. 1880
Cabinet card
6.5 × 4.3 in. (16.5 × 11 cm)
NSU Art Museum Fort Lauderdale;
William Glackens Archives
Collection, ARC2021.23.a

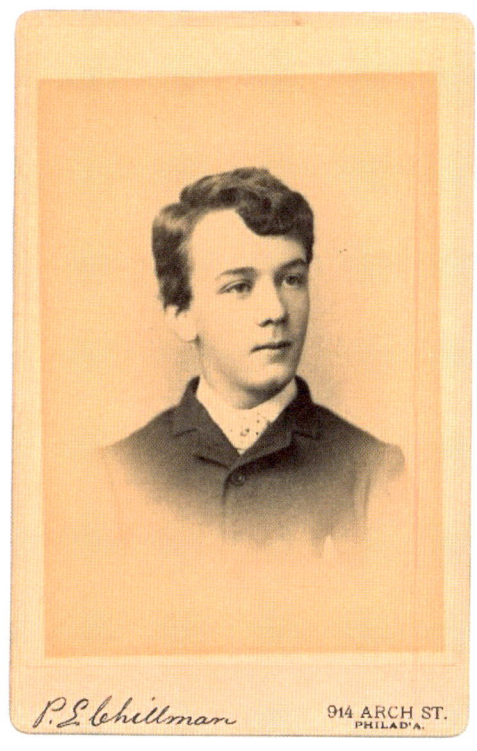

Foreword

Avis Berman

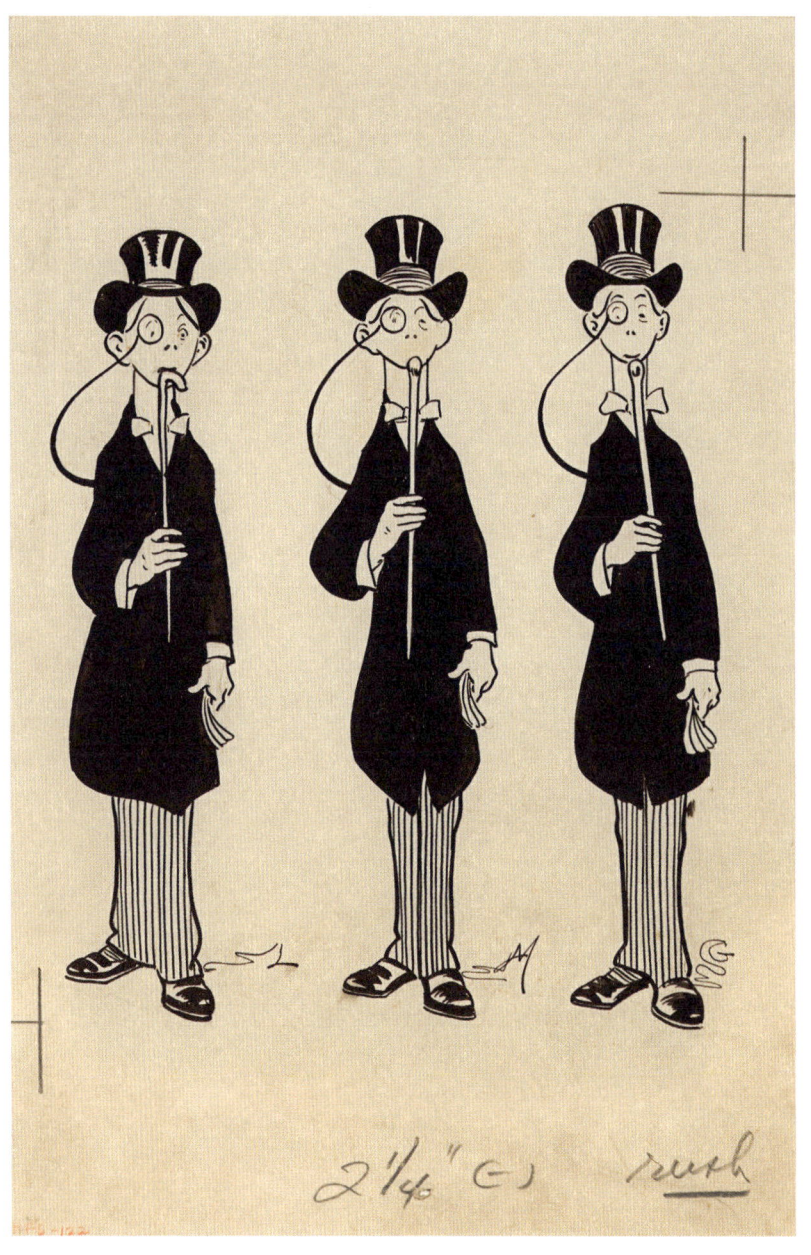

The Glackens family was nothing if not creative. William Glackens' paintings, drawings, and illustrations are essential to the story of American art, and his wife, Edith Dimock Glackens, specialized in watercolor. She exhibited regularly for thirty years, and her work was purchased by such visionary collectors as John Quinn and Albert C. Barnes. Their children, Lenna and Ira, painted and drew as natural activities; as adults, they both became writers. Moreover, all four members of the family have been commemorated in a number of publications and exhibitions.

The striking exception to this record of public recognition has been Louis M. Glackens, William's talented older brother, whose prolific career as a book and magazine illustrator has been overlooked until now. His mind ran to fantasy rather than realism, yet he displayed a versatility necessary for a working cartoonist: he could glide with ease from fairy tales for children to salient political and social issues of the day. (Literally and figuratively, William Howard Taft was one of his biggest targets.) These accomplishments are documented for the first time through the exhibition *Louis M. Glackens: Pure Imagination* and its accompanying catalogue. Richard Samuel West, in his catalogue essay, presents an authoritative portrait of *Puck*, the nation's influential humor magazine, and Glackens' primary employer from 1893 to 1914. Ariella Wolens' interpretative essay situates Glackens in the context of his time, focusing on some of his most important cartoons to highlight his fluid draftsmanship and skill at fusing whimsy with satire.

The Sansom Foundation, which was established by Ira Glackens and his wife, Nancy Middlebrook Glackens, is pleased to support the NSU Art Museum Fort Lauderdale pioneering exploration of Louis Glackens' life and art. The exhibition's contribution to Glackens literature adds another chapter to the history of American illustration and will introduce new audiences to an underappreciated artist whose witty and joyous work deserves to be much better known.

Fig. 1.1 *Three Identical Men in Top Hats with Monocles*, 1903
Puck, December 31, 1903
Ink on Bristol board
12.1 × 8.2 in. (30.7 × 20.8 cm)
Delaware Art Museum, gift of Helen Farr Sloan, 1978

Introduction
Ripped from Yesterday's Headlines!

Bonnie Clearwater

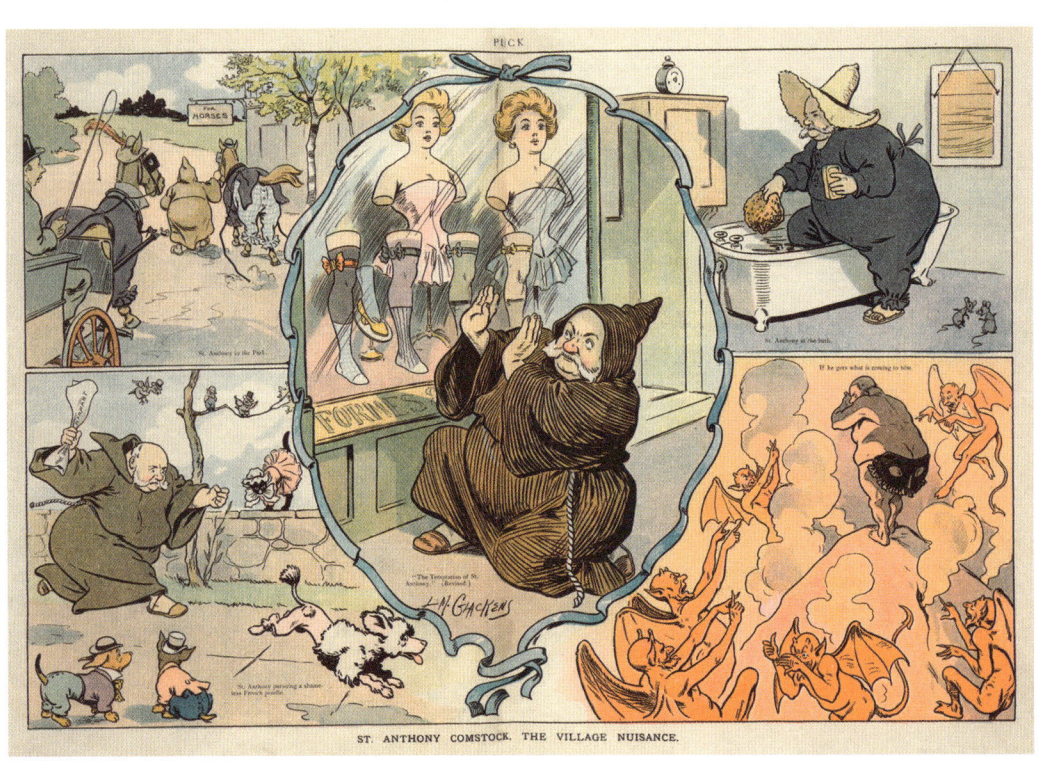
ST. ANTHONY COMSTOCK, THE VILLAGE NUISANCE.

Consumers chasing the Cost of Living!!
Politicians courting constituents!!
The Comstock Act!!

These and other satirical subjects drawn by Louis M. Glackens (1866–1933) lampooned the politics of early twentieth-century America. Yet his drawings prove the adage "the more things change, the more they stay the same," as their timelessness continues to lend itself to current issues. *The New York Times*, for instance, selected Glackens' 1906 cartoon, "St. Anthony Comstock, the Village Nuisance" (fig. 2.1), to illustrate a 2023 opinion article regarding the resurrection of the obscure anti-obscenity Comstock Act of 1873 by lawmakers in Texas, Oklahoma, and elsewhere, with the aim to ban books, drag performances, and medical abortions.[1] In the June 2024 issue of *The New Criterion*, James Pierson's review of Jacob Heilbrunn's book *America Last* was accompanied by Louis' 1909 illustration "No Limit" for the cover of *Puck*, depicting international leaders playing a high-stakes card game with the naval arms race (pl. 20).[2]

One can only imagine the fun the Glackens family enjoyed as the artistic brothers William (1870–1938) and Louis matched wits and turned their gleeful eyes on a rapidly changing world. William J. Glackens' wife, artist Edith Dimock Glackens (1876–1955), and children Ira (1907–1990) and Lenna (1913–1943) exhibited a humorous streak as well. Edith, for instance, provided an insider's take on the hustle and bustle within a women's dressing room in Klein's department store on New York's Union Square (fig. 2.2), while Lenna's comical side is evident at the precocious age of nine in *Two Figures-Sphinx* (1922), a drawing which pairs an Egyptian sphinx in the upper register with a modern young girl assuming the same pose below. Both figures sport the ponytail of the clever young artist (fig. 2.3). Ira's drollery imbues his writing, including the satire *Pope Joan: the English Girl Who Made It* (published 1964) and the painting of the same subject (Collection NSU Art Museum Fort Lauderdale). The family's playfulness was even exhibited by William and Edith's Standard Poodle, christened "Imp." The pet was memorialized in drawings and paintings by William as well as in a thank you card inked by their friend, the famed illustrator Ludwig

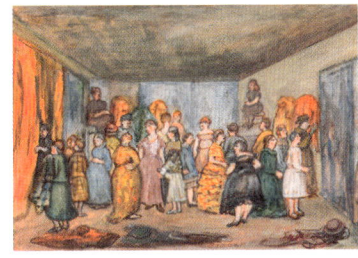

Fig. 2.1 "St. Anthony Comstock, the Village Nuisance,"
August 22, 1906
Puck, vol. 60, no. 1538 (centerfold)
Photomechanical offset color print
William Chrisant & Sons' Old Florida Book Shop, Fort Lauderdale

Fig. 2.2 Edith Dimock Glackens
Trying on Room, Klein's, Union Square, n.d.
Watercolor on paper
10.8 × 15.5 in. (27.4 × 39.7 cm)
NSU Art Museum Fort Lauderdale; bequest of Ira D. Glackens, 91.40.75

Bemelmans, depicting the moment that the giant Imp pounced on him during his visit to their home (fig. 2.4).

William initially followed in his older brother's footsteps as a prominent illustrator for the popular magazines and publications that proliferated during the early years of the twentieth century. While Louis—as illustrator for the nation's leading satirical magazine *Puck*—directly skewed the politics of the day, William swiftly captured the daily comedy of urban life in his drawings, including his composition for a two-page spread in *Collier's Weekly* rendering the hordes of scurrying Christmas shoppers contending with New York's Fifth Avenue's billowing winds, carriages transporting towering gift packages, Sidewalk Santas, and even pick-pockets (fig. 2.5).

Holiday scenes, such as Christmas and the Fourth of July, are among the few subjects that the brothers shared that thereby provide telling comparisons of their styles and perspectives. Louis' *Puck* cover for June 28, 1911, lampoons the spectacle produced by the wasteful Independence Day extravagance of a rich man's detonation of a $20,000 battleship to dazzle onlookers (pl. 26). The Fourth of July held personal meaning, for William, as it marked the birth of his son in 1907. For Ira's birth announcement, William drew the newborn propelled on a rocket, high above Washington Square Park near the family's home in New York's Greenwich Village (Collection NSU Art Museum Fort Lauderdale). For his *Collier's Weekly* magazine illustration *Patriots in the Making*, William depicted himself and Edith (holding little Ira) perched high on a fire escape in Manhattan's Lower

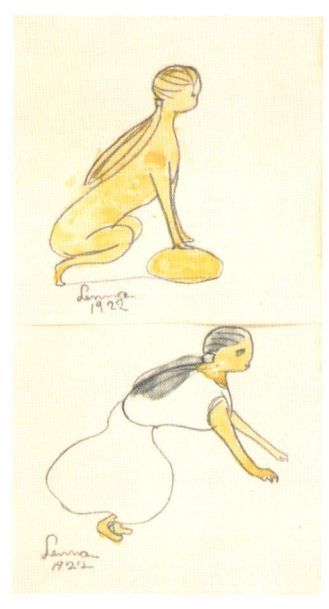

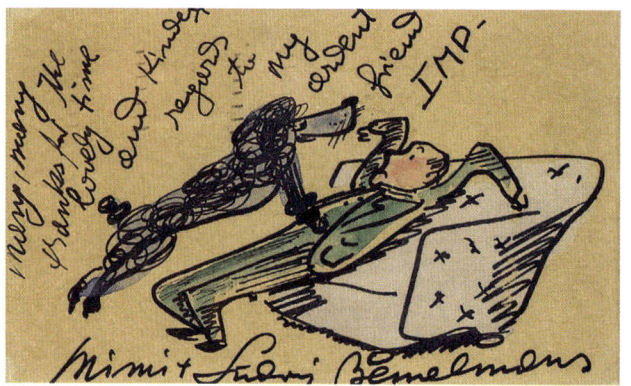

Fig. 2.3 Lenna Glackens
Two Figures-Sphinx, 1922
Graphite and watercolor on two leaves of wove paper
7 × 4 in. (17.8 × 10.2 cm)
The Barnes Foundation, BF7588

Fig. 2.4 Ludwig Bemelmans
Man and French Poodle on Couch, n.d.
Watercolor and ink on paper
3.3 × 5.3 in. (8.3 × 13.4 cm)
NSU Art Museum Fort Lauderdale, gift of The Sansom Foundation, Inc., 2020.10

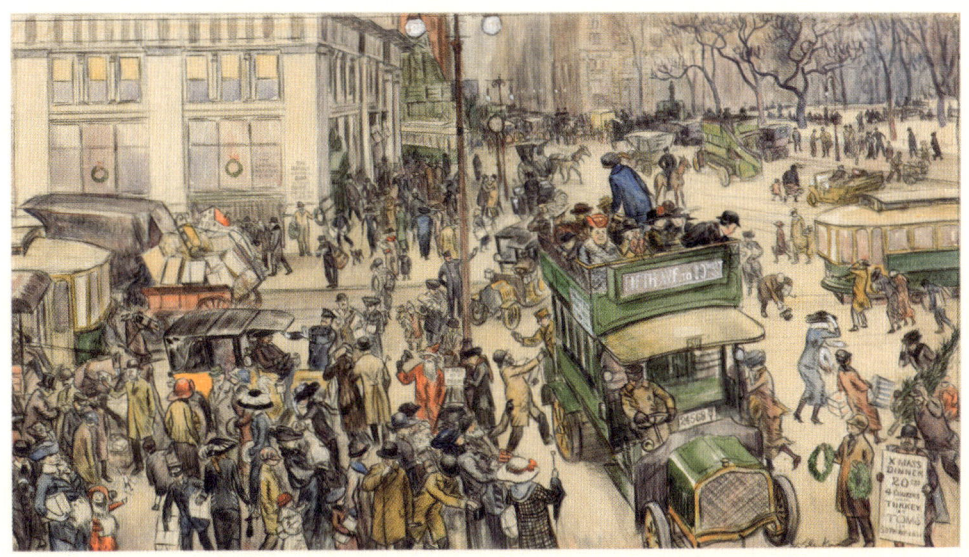

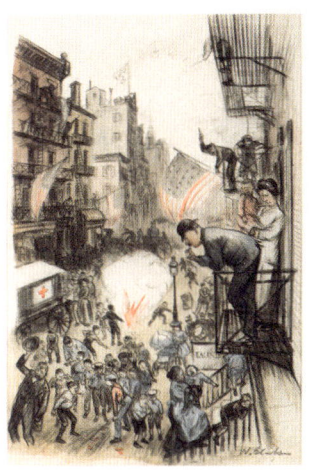

Fig. 2.5 William J. Glackens
Christmas Shoppers, Madison Square, 1912
Conté crayon and watercolor on paper
16.8 × 31.9 in. (42.6 × 81 cm)
NSU Art Museum Fort Lauderdale; bequest of Ira D. Glackens, 91.40.106

Fig. 2.6 William J. Glackens
Patriots in the Making, 1907
Conté crayon and watercolor on paper
20.5 × 13.8 in. (52 × 35 cm)
NSU Art Museum Fort Lauderdale, gift of Patricia O'Donnell, 2017.7

East Side as they gaze upon the madcap scene below: immigrants celebrating the birth of their newly adopted nation with exploding firecrackers and pistols blasting bullets skyward, while an ambulance tends to the wounded and a horse-drawn fire truck speeds towards the next emergency (fig. 2.6). American flags calmly wave above this melting pot of patriots in the making. In this comparison, Louis' critique of the wealthy elite lands a punch, whereas William remains an objective reporter who avoids passing judgment. Although Louis and William mostly shared the same progressive politics, one can surmise that in his 1905 cartoon "JUST SUPPOSE" (pl. 9) Louis was poking fun at the women's suffrage movement at the expense of staunch supporters William and Edith, as he flipped the power struggle between men and women to the extreme. Still, his drawing *Happy New Year Votes for Women* (December 27, 1911) signals his support of women's hard-won right to vote (pls. 30, 31).

William's mastery of drawing and illustration served him well as a painter and leading figure in American realism. However, despite the spontaneous appearance of his paintings, he augmented reality by imaginatively reworking each composition in a multitude of drawings and sketches (figs. 2.7, 2.8, 2.9). Nevertheless, William's paintings remained rooted in the present, whereas Louis

often found it conducive to resurrect days of yore, or plumb his fancy for comedic commentary on the human condition.

Both brothers played significant roles in ushering the art of the modern era in America. Although committed to realism, William was responsible for helping to introduce modern art to America as advisor to Albert C. Barnes' collection, as well as taking the lead on the American committee for the Armory Show New York (1913) and serving as president of the board for the American Society of Independent Artists, where he presided over Marcel Duchamp's controversial submission of *Fountain*, a store-bought urinal, to the association's exhibition in 1917. Louis, for his part, not only set the pace for the genre of political satire that reverberates in the monologues of Stephen Colbert and Jon Stewart today, but his ingenious experimentation with the new twentieth-century medium of cartoon animation opened up possibilities for subsequent generations. Louis Glackens may have been born too soon, but it seems safe to say, his time has come.

[1] Michelle Goldberg, "The Hideous Resurrection of the Comstock Act," *The New York Times*, April 8, 2023.
[2] The cartoon is attributed to "anonymous" on the book review's webpage, James Piereson, *The worst book of the year*, *The New Criterion*, accessed June 13, 2024, https://newcriterion.com/article/the-worst-book-of-the-year/.

Fig. 2.7 William J. Glackens
The Bandstand, 1919
Oil on canvas
24.3 × 29.3 in. (61.7 × 74.4 cm)
NSU Art Museum Fort Lauderdale, gift of The Sansom Foundation, Inc., 92.29

Fig. 2.8 William J. Glackens
Untitled, c. 1919
Charcoal and gouache on paper
4.9 × 6.8 in. (12.4 × 17.2 cm)
NSU Art Museum Fort Lauderdale; bequest of Ira D. Glackens, 91.40.47

Fig. 2.9 William J. Glackens
Sketchbook, c. 1919
Charcoal and graphite on paper
5 × 7.8 in. (12.7 × 19.8 cm)
NSU Art Museum Fort Lauderdale, gift of The Sansom Foundation, Inc., 92.68.27

17

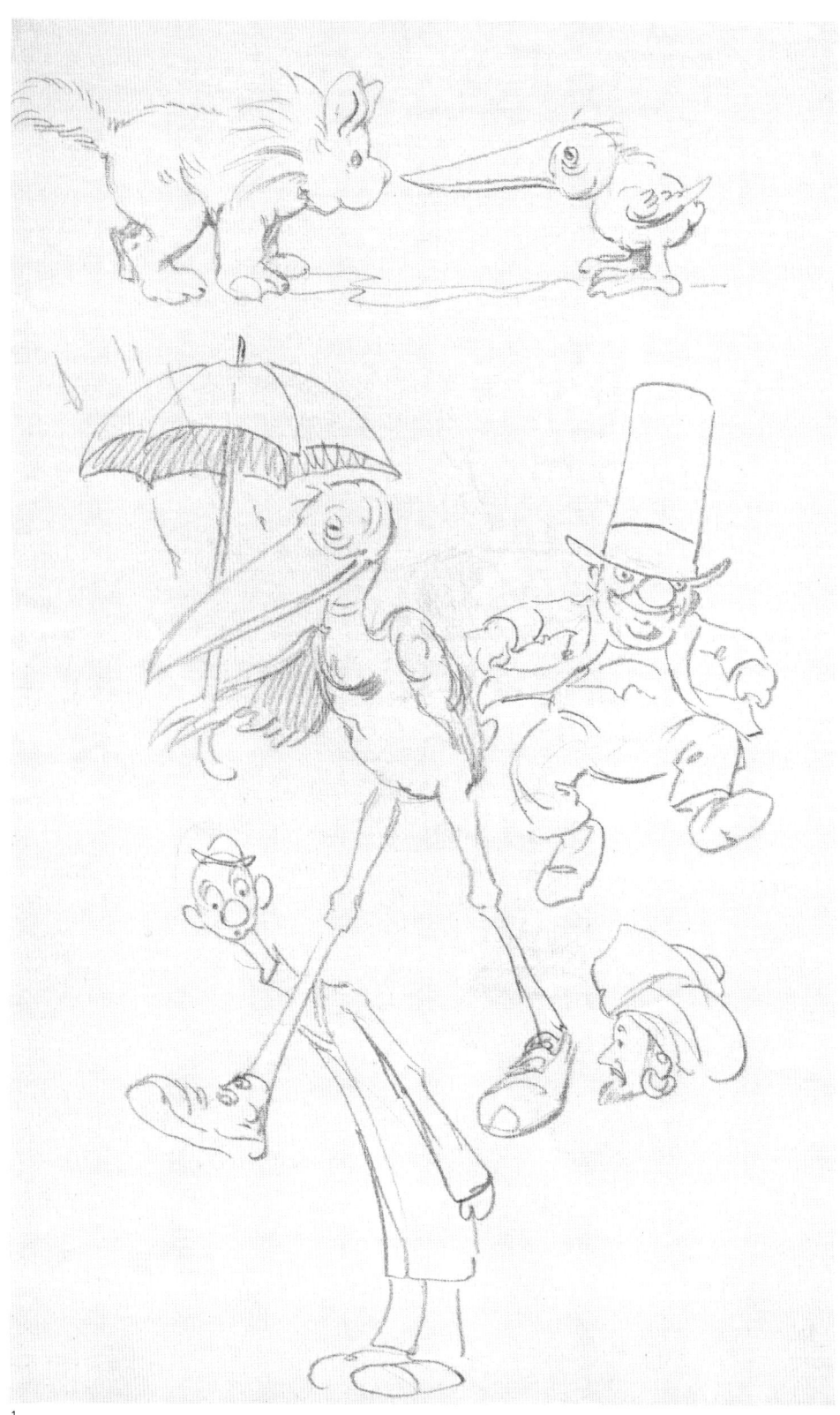

Pls. 1–7 Louis M. Glackens
Untitled, n.d.
Graphite, colored pencil
on paper
Dimensions variable
NSU Art Museum Fort Lauderdale;
bequest of Ira D. Glackens

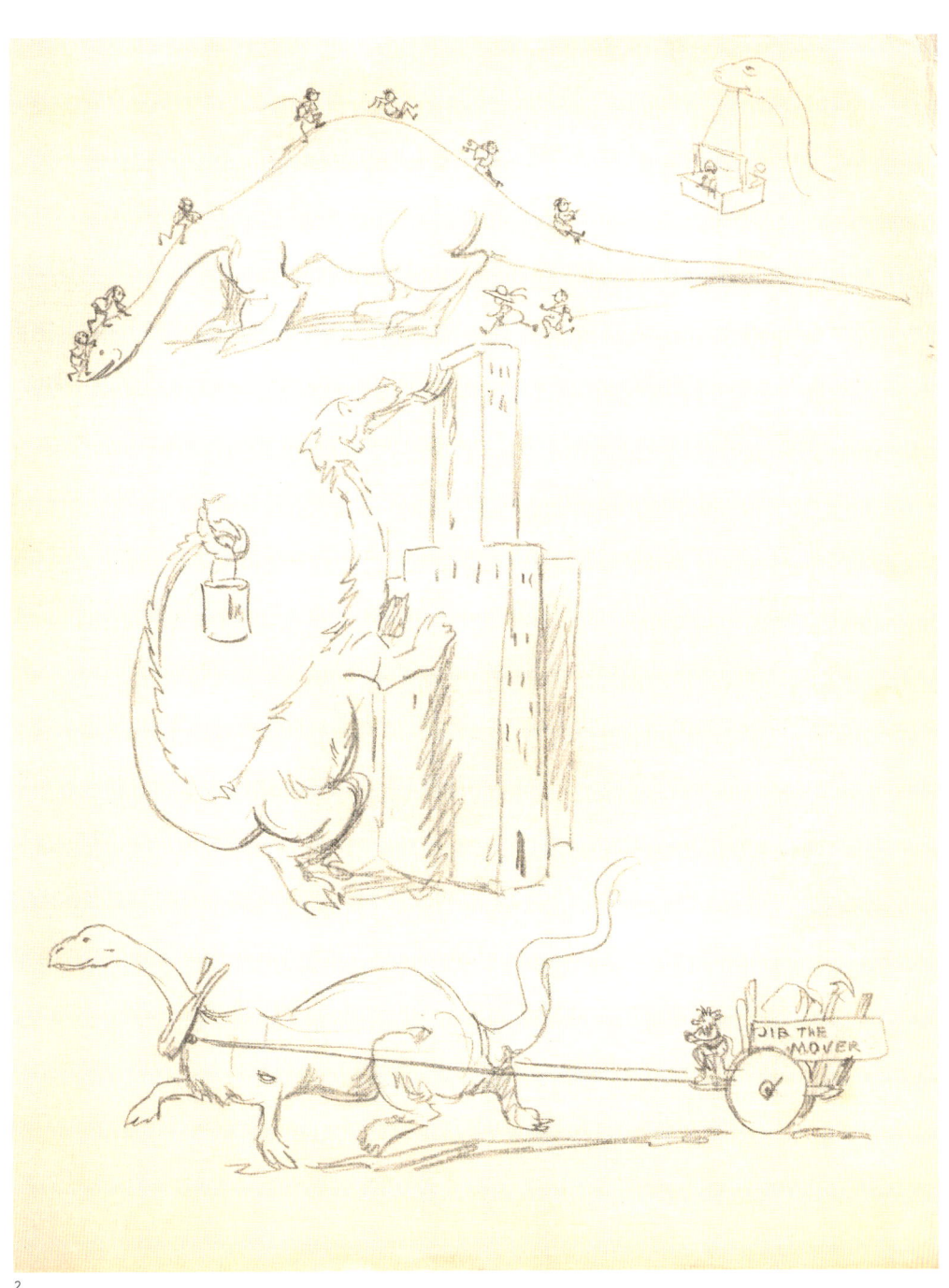

4

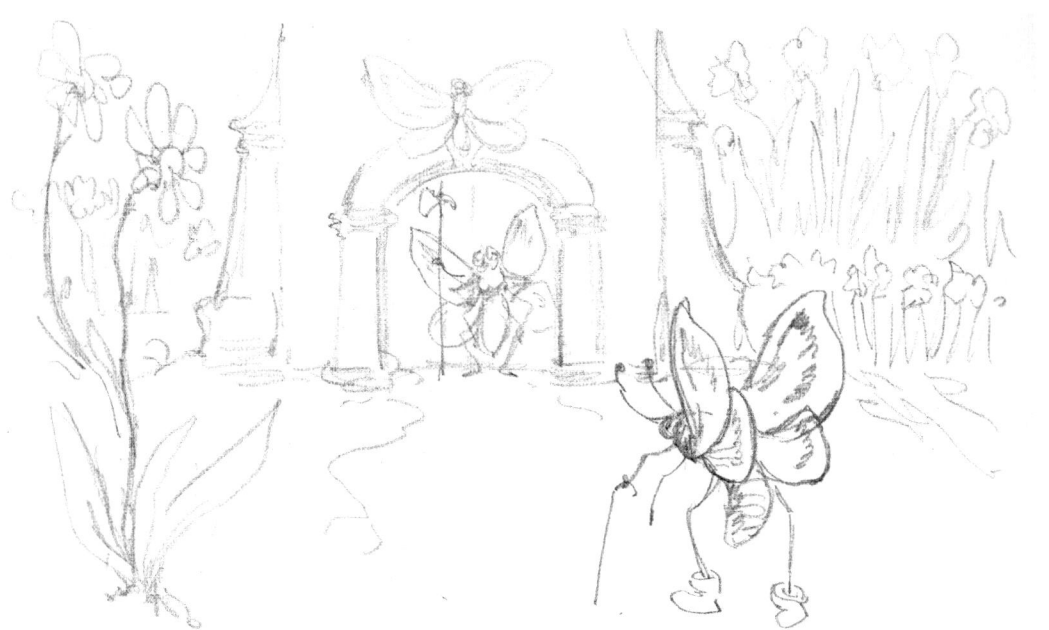

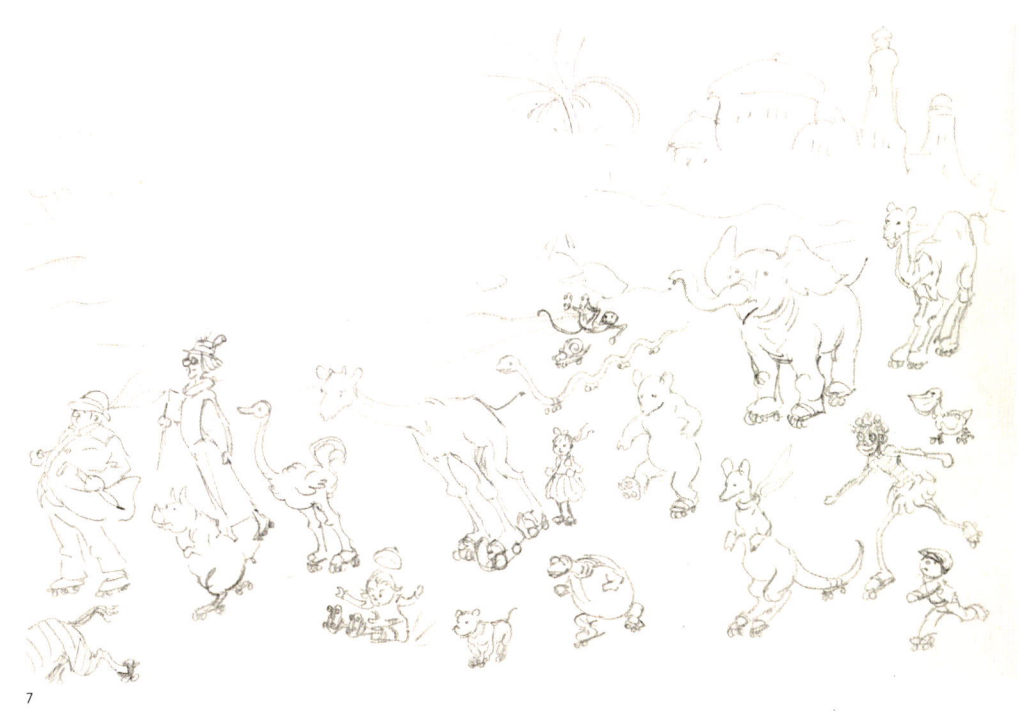

Born Too Soon:
The Life of
Louis M. Glackens

Ariella Wolens

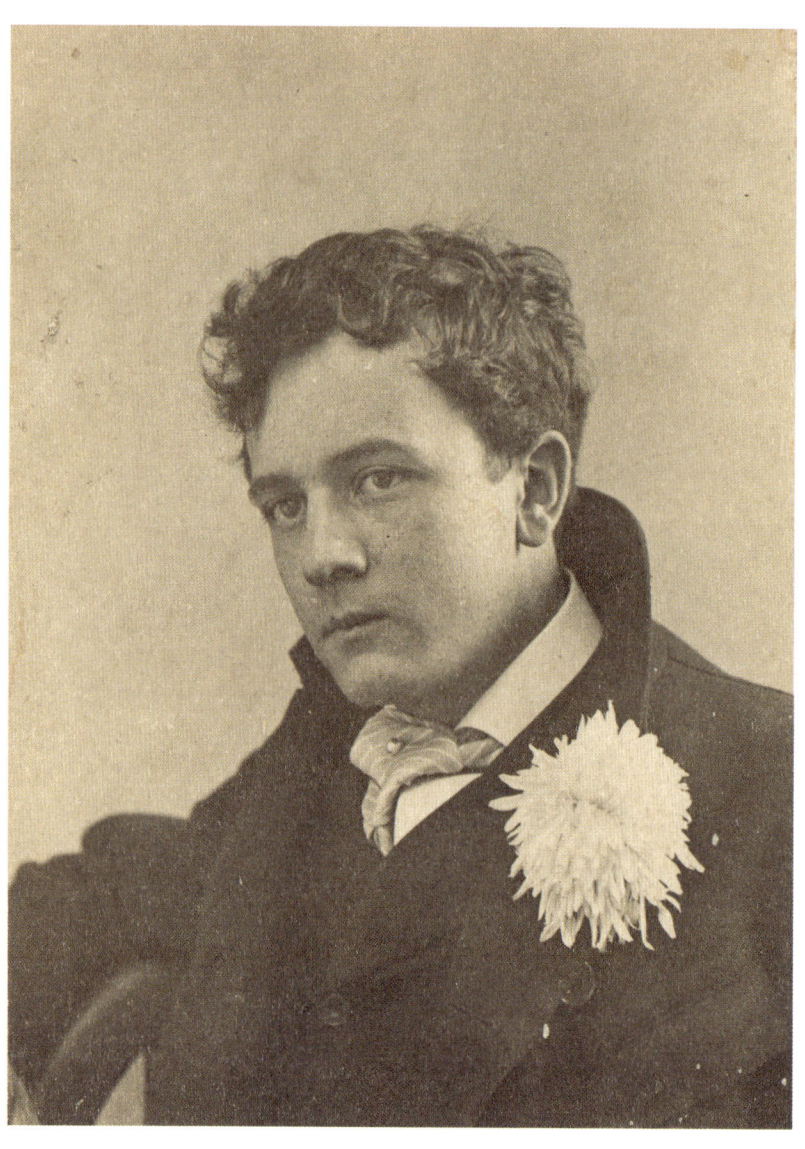

The exhibition, *Pure Imagination*, is an overview of the life and work of artist Louis M. Glackens (b. 1866, Philadelphia, PA; d. 1933, Jersey City, NJ), a trailblazing figure who, in 1913, became one of the first cartoon animators, creating characters for production houses such as Bray and Pathé Studios. His fantastical depictions of mermaids, anthropomorphic beasts, and pie-faced grown-ups carved a path within this burgeoning industry, establishing the language of children's storytelling that later manifested into the world of Walt Disney. From 1893–1914,[1] Glackens served as a staff artist for the weekly magazine *Puck*, the first successful political humor periodical in the United States.[2] Regrettably, the artist was out of step with the fashion of his time and bore the curse of the avant-garde. As such, his prolific contribution to the history of cartoons and illustration has remained largely unexplored. Until now, he has been relegated to an aside within the narrative of his younger brother, William. While both brothers "drew in the cradle,"[3] a compulsion that stayed with them throughout their lives, it seems that Louis Glackens had the misfortune of, in the words of his nephew Ira Glackens, being "born too soon."[4] Like William, Louis had a discerning eye through which he observed the human condition. However, while his brother's artistry was formed in the realist ethos of the Ashcan School, the elder Glackens chose to deliver his take on reality through a more fable-like world, in which the absurdity of life was captured through an economy of line and an abundance of wit.

Louis Maurice Glackens was born in Philadelphia on May 4, 1866, to Elizabeth (née Finn) and Samuel Glackens.[5] Samuel supported the family as a clerk and cashier for the Pennsylvania Railroad, earning enough for them to live comfortably at 3214 Sansom Street, near the Schuylkill River. The family later moved to nearby Cherry Street, a desirable location off Logan Square. Louis grew up with his siblings Ada Glackens (b. 1869, Philadelphia, PA; d. 1931, Philadelphia, PA) and William, in what has been described as a modest and peaceful home.[6] The family was of Irish and German extraction, with their mother's side having immigrated to Pottstown, Pennsylvania, from Palatinate, Germany. Their patrilineage descended from County Donegal, Ireland.

Fig. 3.1 Photographer unknown
Portrait of Louis Glackens,
December 1891
Cabinet card
Richard Samuel West Collection

Upon arriving in America around 1818, Louis' great grandfather, Daniel Logue Glacken (Gaelic for "little hand") had added an "s" to his surname, to sound more pleasing to the ear. Daniel went on to have a career as a master printer and founded a local Pottstown newspaper, *The Lafayette Aurora*. In doing so, he established a precedent for his great-grandchildren's foray into the publishing world.[7]

Louis graduated from the prestigious Central High School in Philadelphia as vice president of his class in 1886.[8] Lou, as he was known throughout his life, was said to have entertained students and teachers by making impromptu caricatures of various school personalities.[9] Other notable Central High alumni from this time included industrialist Simon Guggenheim (1867–1940), politician Leo Stanton Rowe (1871–1946), chemist and art collector Albert C. Barnes (1872–1951), and Ashcan School artist John Sloan (1871–1951).[10] Following his graduation from Central High, Glackens initially stayed close to home, studying at the Pennsylvania Academy of the Fine Arts,[11] before seemingly transferring to the Art Students League of New York in the late 1880s.[12] Louis' time at the school briefly preceded that of his future sister-in-law, Edith Dimock Glackens, whom he lovingly called "Teed."[13]

Like much of his biography, the details regarding Louis Glackens' start in the professional realm are nebulous. In having the misfortune of being "born too soon," Glackens is like many posthumously recognized artists, whose early careers and personal histories have slipped through archival cracks. What consensus there is regarding his beginnings as an illustrator settles upon Glackens initially working for New York-based publisher, Frank A. Munsey (1854–1925), founder of boyhood pulp magazines *The Argosy* (1888–1978), a continuation of *The Golden Argosy* (1882–88), and *Munsey's Weekly* (1889–91), later named *Munsey's Magazine* (1891–1929). According to Ira Glackens, his Uncle Lou often signed his work under multiple pseudonyms, thereby making it difficult to identify much of his early output (in which his visual style was also inevitably evolving).[14] This confusion seems to have been intentionally orchestrated by Munsey, who also assigned multiple pen names to

contributors H. P. Lovecraft, Horatio Alger Jr. and Johnston McCulley, creator of the vigilante character, *Zorro*. In Alger's *New York Times* obituary, it states that, "[Munsey] the business-minded publisher encouraged the use of the Alger pseudonyms to get as much work out of him as he could."[15] Despite Munsey's efforts to hide the identity of his contributors, Glackens managed to start making a name for himself as an illustrator.

The earliest illustrations that can be verifiably attributed to Louis Glackens are his drawings for the novel *The Last Tenet Imposed Upon the Khan of Tomathoz* (1892), created when he was around 26 years old. Twenty ink drawings accompany this story of a sixteenth-century missionary voyage to Central Asia. At the center of the story is the Khan of Tomathoz, "an excessively corpulent man . . . exceedingly wicked, even for an eastern potentate"[16] (fig. 3.2). The colonialist tale employs humor and romance as a foil for malign fears about the foreign unknown, to which Glackens added the type of racial and ethnic caricaturing that prevailed in the late nineteenth century.

A year after the *Khan of Tomathoz*, Glackens would get his first job with *Puck* magazine. The paper was originally founded in September 1876, by a young Viennese American cartoonist named Joseph Keppler (1838–1894) and German American printer Adolph Schwarzmann (1838–1904). Together, the old-world émigrés created the German-language magazine *Puck: Illustrirtes Humoristisches Wochenblatt* (Puck: Illustrated Humor Weekly). In March of

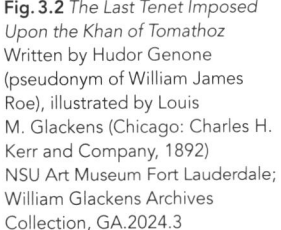

Fig. 3.2 *The Last Tenet Imposed Upon the Khan of Tomathoz* Written by Hudor Genone (pseudonym of William James Roe), illustrated by Louis M. Glackens (Chicago: Charles H. Kerr and Company, 1892) NSU Art Museum Fort Lauderdale; William Glackens Archives Collection, GA.2024.3

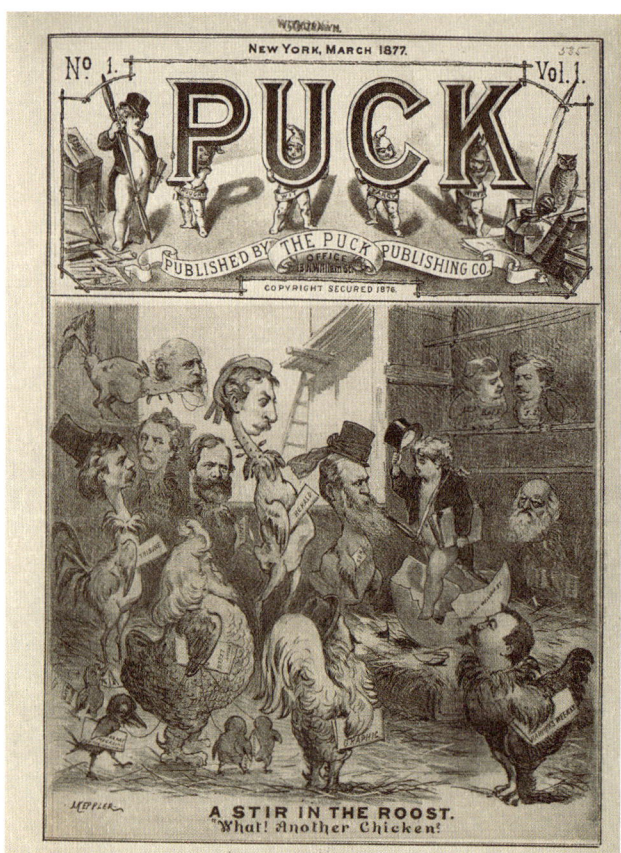

Fig. 3.3 *Puck* magazine, first English edition March 14, 1877, vol. 1, no. 1 Cover by Joseph Keppler

the following year, they launched an English language edition as well (fig. 3.3). The magazine was modeled on European satire publications that, thanks to the accelerating sophistication of the industrial printing press, had become ubiquitous. Defining titles such as the French *Le Charivari* (a folk term essentially meaning "the public shaming"), the British *Punch*, Austrian *Kikeriki* (a German phrase equivalent to "cock-a-doodle-doo") and *Der Floh* (The Flea) laid the historical groundwork for *Puck*.

Puck's name was an homage to the cheeky cherub from Shakespeare's *A Midsummer Night's Dream*. In the Elizabethan play, Puck functions as the audience's interlocutor, breaking the fourth wall to provide commentary on the foolishness of its human players. The magazine's slogan quoted Puck's famous line, "What fools these mortals be!" Following this allegorical model, *Puck* magazine offered biting criticism on the

political vagaries of the day. Their subjects of derision included politicians, tycoons, and bureaucratic overlords. Among the crowd-pleasers featured heavily in the magazine were presidents Ulysses S. Grant, Grover Cleveland, Theodore Roosevelt (its most frequently recurring character), and Louis Glackens' personal favorite, William Howard Taft. Readers would also be sure to recognize the caricatured renderings of political bosses like William "Boss" Tweed and Thomas B. Reed, alongside robber barons like John D. Rockefeller, J. P. Morgan and Cornelius Vanderbilt.[17] The pictorial facility of *Puck*'s illustrators meant the publication could churn out timely critiques that responded to the rapidly changing news of the day. *Puck*'s artists' talent was strengthened by the implementation of efficient, high-quality printing technologies such as chromolithography and color separation; guided by its discerning editors, the magazine sustained profitability and produced weekly issues for almost forty years. The final issue of *Puck* appeared on September 7, 1918. The impact of this public loss was acknowledged by the *Literary Digest* with the following epitaph, "*Puck* had no real rival in its best days. Fallen from its fine estate, it has left no successor."[18]

Glackens' debut at *Puck* took place during the 1893 World's Fair in Chicago, where the magazine had been honored with a dedicated pavilion in the center of the Jackson Park fairground. Small but heraldic, the building

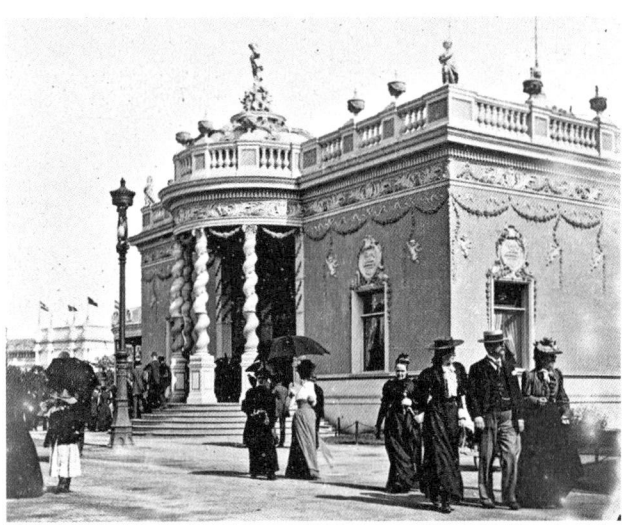

Fig. 3.4 Puck Pavilion, reproduced in *Glimpses of the World's Fair: A Selection of Gems of the White City Seen Through a Camera* (Chicago: Laird & Lee, 1893) "The entire color printing process of the *World's Fair Puck* can be witnessed here using six [R.] Hoe presses and artists' and engravers' rooms."
People's Register, PA

was ornately decorated with corkscrew columns and bas-relief images of fairies (fig. 3.4). The purpose of the space was to showcase the magazine's pioneering work in the field of color printing. Each week, a *World's Fair Puck* special edition was published. The public was invited to stand and watch as the editors, illustrators (including newly hired Glackens), and printers toiled away. The first drawing *World's Fair Puck* published by Glackens shows an exposition visitor observing a figure from a "Human Zoo" (see p. 49), a common spectacle in the nineteenth and early twentieth century, in which foreigners and people with biological anomalies were put on display like objects. The visitor questions the "Living Skeleton" as to whether he has had "the dropsy," meaning edema, a condition caused by malnutrition. In choosing this subject, perhaps Glackens was making a veiled comment on the *Puck* staff's own feelings of being treated as curios for public consumption.

After his stint at the Chicago World's Fair, Louis Glackens slowly built his reputation at the *Puck* offices in New York, putting out a smattering of content while also assisting with print production for his first few years.[19] It was not until the turn of century that his star began to rise. Keppler and Schwarzmann made ample use of Glackens' fluid and distinct line, which ensured the jokes within these political vignettes remained legible among the vibrant colors and stage-setting details. One political figure whom *Puck* frequently employed Glackens' graphic skill to ridicule was William Howard Taft. Over the course of Taft's rise from Roosevelt cabinet member to chosen presidential successor, to ousted leader, the corpulent statesman served as excellent fodder for Glackens' imagination, resulting in caricatures of the Republican leader caught up in some humiliating scenarios; these tended to involve Taft pandering to the various business leaders and conservatives needed to support his "dollar diplomacy."

Taft was not a popular figure. Lacking the charisma of his predecessor Theodore Roosevelt, he was particularly inept when it came to establishing relationships with the American press. During the Progressive Era (1896–1917), magazines such as *Puck*, along with *McClure's*, *American Magazine*, and *Hampton's*, acted as a direct line to an increasingly educated and

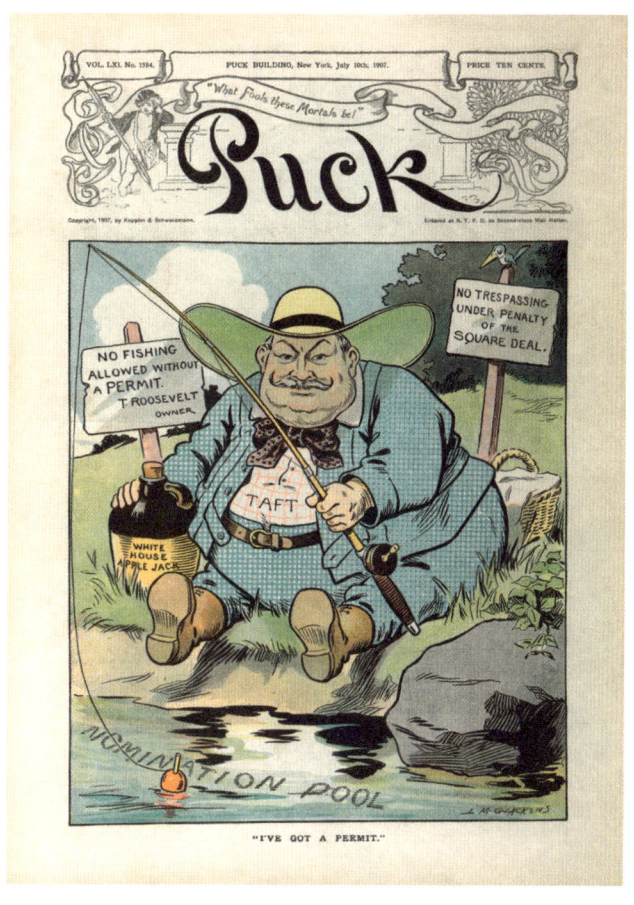

Fig. 3.5 "I've Got a Permit,"
July 10, 1907
Puck, vol. 61, no. 1584
Photomechanical offset color print

politically engaged public. In the 2013 historical biography *The Bully Pulpit*, presidential scholar Doris Kearns Goodwin outlines how this new crop of progressive magazines created a form of intrepid journalism that came to be known as "muckracking," and exposed corruption throughout government and business. Kearns Goodwin goes on to quote philosopher William James' assessment that these publications were dedicated to "the mission of raising the tone of democracy," thereby exerting an elevating influence on public sentiment.[20] *Puck* magazine went about their crusade against injustice by taking up the weapon of satire, subverting the power of the presidency by ridiculing those it deemed insincere.

By 1900, *The Philadelphia Inquirer* had already made personal mention of *Puck* illustrator L. M. Glackens, describing him as a "well-known figure in the newspaper circles of both this and New York City."[21] Though it may

seem apocryphal looking back a century later, there was a time when the reputation of Louis Glackens exceeded that of his brother William. The latter followed behind Lou, working as a police-beat illustrator for newspapers such as *The Philadelphia Record* and *The Philadelphia Press* in the 1890s. In 1898, he was hired by *McClure's* to document the victories and hardships of the US military during the War of 1898 (also known as the Spanish-American War) in Havana, Cuba. It was not until the turn of the century that William shed his artist-reporter skin and made the decision to become a modernist painter. William's skill was bolstered by the support of his equally ambitious friends and fellow Philadelphia illustrators: John Sloan, Everett Shinn, and George Luks. Following the model of the outcast French modernists, the artists banded together with visionary artist Robert Henri to mount their own exhibitions, culminating in *The Eight* show of February 1908 at Macbeth Gallery in New York, which became their cause célèbre. From this point on, Louis and William's positions as artists were separated by the hierarchy which places painting (art for art's sake) above illustration (art as commerce). The creative and class delineations between the brothers were further marked by William's marriage to Edith Dimock, whose family wealth meant that, unlike Louis, he was able to pursue his art unencumbered by financial necessity.

Louis' style was deemed too fanciful once the stark horrors of World War I began to take hold in the 1910s, but his work from this time arguably surpassed the realist pursuits of his brother and Ashcan School peers, in more clearly identifying with the everyman's view of the times. While *Puck* was an equal-opportunist publication that critiqued individuals on both sides of the political aisle, it primarily reflected the social progressive politics of its immigrant founder, Joseph Keppler.[22] *Puck* historians Michael Alexander Kahn and Richard Samuel West offer the following summary of the magazine's ideological stance:

> For most of its run *Puck* was a journal of reform. It crusaded against political corruption, the undue influence of money in politics, and monopolies in all their forms. It advocated for the rights of labor, for fair immigration policies, for tariff reform. During its

more conservative middle years, it supported the gold standard and expansion. Many of the issues that dominated *Puck*'s pages more than one hundred years ago continue to dominate the political debate today.[23]

The directives for *Puck*'s content were given by its editors, literary leader Henry C. Bunner along with founder and chief illustrator Keppler. Illustration concepts and captions were conceived by what Bunner called, "'the idea mongers,' clever men with bright ideas, but no artistic skill."[24] Historian Leroy V. Eid describes *Puck*'s creative output as the result of democratic discussion among the staff, through which "weekly editorials and cartoons reflected a consensus achieved through consultation and collaboration."[25] While Glackens' *Puck* cartoons cannot offer a direct insight into his personal politics, Eid's assertion provides reason to believe that Glackens did more than passively consent to the politics conveyed in these cartoons, and may have gone so far as to share in their sentiment. To what extent he was a passionate advocate or opposer of the issues confronted cannot be fully determined, however there can be no doubt that he was very much in favor of some Puckish provocation.

Louis Glackens unequivocally managed to convey the magazine's populist yet progressive tone through his images, many of which would find themselves well camouflaged among today's *New Yorker* cartoons. One particularly apt example is Glackens' enduringly humorous response to the work presented by a young Marcel Duchamp and his fellow Cubists at the 1913 Armory Show in New York (whose organizers included none other than Louis' brother William). Bearing the caption "The Latest in Easter Eggs," the March 19, 1913 cover (fig. 3.6) depicts a chic mother hen decked out in a beret and flamboyant bow guarding her multicolored geometric nest eggs, a sight which the other farm animals look on in a state of bewilderment. While both Glackens brothers aligned themselves with advocates for independence, this holiday-themed satire epitomizes the ways in which Louis was adroit at combining whimsical narratives with witty yet easily decoded topical commentaries. He manifested these lively illustrations with restrained technical skill; his imaginative and detailed

scenes could be clearly read through his effortless ability. The vitality within his images was only further enlivened by the sumptuous pigments *Puck* and its printers J. Ottmann Lithographing Company had mastered in creating.

Along with entertaining thousands of adult readers, Louis Glackens had a keen audience among children, most notably his niece and nephew Lenna and Ira Glackens. In his memoir, Ira describes his fondness for his Uncle Lou:

> My sister and I adored him because when he came to our house he drew us pictures for hours at a time; his drawings of elves, gnomes and Noah's Ark (fig. 3.7) with the antics of the animals within were part of our childhood. Full of humor and imagination, they flowed from pencil like water from a tap. Like Shakespeare he never blotted a line.[26]

Fig. 3.6 "The Latest in Easter Eggs," March 19, 1913
Puck, vol. 73, no. 1881 (cover)
Photomechanical offset color print

Fig. 3.7 *Untitled*, n.d.
Graphite on paper
5 × 8 in. (12.7 × 20 cm)
NSU Art Museum Fort Lauderdale;
bequest of Ira D. Glackens,
91.40.281

Fig. 3.8 *Untitled*, n.d.
Graphite on paper
8 × 5 in. (20 × 12.7 cm)
NSU Art Museum Fort Lauderdale;
bequest of Ira D. Glackens,
91.40.280

The entertaining sketches described by Ira were subsequently donated to NSU Art Museum Fort Lauderdale and are displayed for the first time within *Pure Imagination*. These drawings were gifted alongside many sketches that Ira Glackens surmised were intended for animated cartoons. One such drawing features a clearly defined cell-like border that encloses a mise-en-scène, in which a princely figure appears at a hilltop castle having just discovered a stowed away treasure chest. In looking at such imagery, visions of Disney's later cartoons like *Snow White and the Seven Dwarfs* (1937) and *Sleeping Beauty* (1959) are inevitably conjured. Perhaps Ira Glackens was right in thinking his uncle could have had enormous success had he been in the right place at the right time (fig. 3.8).

Lenna Glackens lived a comparatively shorter life than her brother Ira, leaving her direct insights of Louis unknown. However, it seems Lenna was particularly close to her Uncle Lou, who wrote to her at boarding school and was entrusted in caring for her pet turtles. There is surviving correspondence in which Glackens drew illustrations for his niece that are as vivid as his work for *Puck*. In one letter he relays:

There is one old lady who, I fondly believe, imagines herself a brigadier general as she waddles along but I call her the brig as she moves like a ship wallowing in the sea, and a rough sea, at that. I am sure she is an aristocrat as no one else would dare to dress in such a manner of clothing[27] (fig. 3.9).

The letter finishes with the sign-off, "I am Uncle Lou."[28] This tender and borderline existential closing statement is a profound summation of how Louis Glackens may have seen himself. As a man who never married or had children, and lived with an irrepressible imagination, he was an avuncular ideal.

Ira Glackens describes his uncle as having lived in a state of arrested development, in which his natural ability resulted in a stubborn refusal to adapt. He attributes his intractability to the favoritism he experienced early in life as the first-born son, observing that, "he was the only child whose picture [grandmother] bothered to have taken."[29] The conclusion of Ira's psychoanalysis of his uncle is fittingly fable-like: "He was considered the more talented of the two brothers. That was his limitation: his facility settled him into a mold from which he would never emerge."[30]

Louis Glackens' professional decline follows the demise of *Puck* magazine, which in January 1914 was sold to Macy's heir Nathan Straus Jr., who decided to take the magazine in a new (and short-lived) direction that saw most of the staff cut loose. Glackens went the way of numerous other illustrators of the time, including fellow *Puck* cartoonists Helena Smith-Dayton (one of the first artists to create stop-motion Claymation) and Henry "Hy" Mayer, and tried his hand at animation. Early animation films were introduced to the public within new purpose-built movie theaters which by 1914 had begun to replace makeshift nickelodeons, transitional spaces in which screens were fashioned out of stretched muslin mounted in vacant storefronts, primarily serving an audience of working-class immigrants.[31] Glackens and his fellow pioneers provided the studios with a taste test, allowing them to gauge how best to compete with the live action blockbusters created by filmmakers such as Charlie Chaplin (who also hopped on the animation band wagon)

Fig. 3.9 *Untitled (Letter from "Uncle Lou" to Lenna Glackens)*, December 6, 1929
Pen on paper
NSU Art Museum Fort Lauderdale; bequest of Ira D. Glackens, ARC2021.990

and D. W. Griffith, best known for his infamous epic about the heroic force of the Ku Klux Klan, *The Birth of a Nation* (1915). Unfortunately for Glackens and his peers, the animation industry would not see true success until the 1930s, when Walt Disney made the world changing decision to transition from shorts to feature-length animations featuring synchronized sound, the first being *Snow White and the Seven Dwarfs* in 1937.

In total, Louis Glackens is credited with making 22 known film titles between 1913 and late 1920.[32] His work with production houses such as Bray, Pathé and Sullivan Studios included both comedic entertainment and educational content, such as *Our Bone Relatives* (1918), a 28 mm celluloid animation that introduces audiences to the concept of Darwinism. In the film, Glackens explores the potential of cel animation to seamlessly transform characters into different shapes, forms, and even species. These projected images were made with pen and ink on acetate sheets, a time-consuming process which requires thousands of frames (16 per second) be manually administered. *Our Bone Relatives* transports the viewer into a classroom; a pointer appears from beyond the frame making didactic motions on a blackboard, a conceptual device that cleverly exploits the vast expanse of blank, black space within each frame. This off-screen presence

Fig. 3.10 Louis M. Glackens and William J. Glackens
Portrait of Lenna, c. 1930s
Oil on canvas
31.2 × 27.2 in. (79.4 × 69.2 cm)
NSU Art Museum Fort Lauderdale,
N.2015.4.20.4

explains the shared origins of animals and humans, and the journey from quadrupedal to upright locomotion. In the closing segment, Glackens wittily illustrates 6 million years of evolutionary progress by depicting a frock-tailed gentleman in a refined pose, next to the skeletons of a primate and elephant attempting to mimic this contrapposto stance (fig. 3.11).

Animation provided a new capacity of creative space for Glackens' abundant imagination. His predilection for caricatured exaggeration, anthropomorphism, and physics-defying slapstick could be realized with unprecedented effect. In films such as *When Knights Were Bold* (1915), Glackens relays a fairy tale in which, "ye gallant knight Sir Harold Hacklehead," boldly takes on the royal-set challenge of destroying "Cruncho . . . the man-killing Geewhizzicus." Should he succeed, Hackelhead will win the hand of "Princess Munnybags and her weight in gold as a dowry."[33] Her royal highness Munnybags is a sensationally vulgar and tragically, light-weight woman, who the knight reacts to seeing for the first time following his achieved mission, by looking out to the audience with a mix of consternation and horror. Glackens' childlike fondness for silly names and folkloric storytelling is balanced with a sprinkling of cheeky barbs thrown in for the adults, such as when Sir Hacklehead tries to trick the elusive monster into emerging from his cave by leaving a classic bottle of red vintage by the entrance to his lair (fig. 3.12). While these early films may appear incredibly

Fig. 3.11 *Our Bone Relatives*,
April 1, 1918
J. R. Bray Studios
Digitized 28 mm black-and-white silent film
3 minutes, 6 seconds
George Eastman Museum

sophisticated by today's audiences, they were not well received by studio heads of the time. This included J. R. Bray, who deemed Glackens "no good" at this new endeavor.[34] Glackens' last known film is believed to be *Eternal Nature* (August 31, 1920), for which no known print survives. Following this, it seems he struggled to find work.

Glackens had also tried his hand as a graphic designer, working for S.S. Adams Company, a prank toy manufacturer founded by Danish immigrant Samuel Sorenson Adams in 1906 in Plainfield, New Jersey. The company is famous for inventions such as the Joy Buzzer. (Introduced in 1928, the toy ironically went on to have phenomenal success during the Great Depression: "The items provided cheap laffs just when the country needed them."[35]) There was also the Cachoo Sneeze Powder (Adams' first invention), Laff Tissue and the Snake Nut Can. In the foreword to *Life of the Party: A Visual History of the S.S. Adams Company*, Chris Ware writes, "If you grew up in America in the last ninety years, some image, phrase or object [related to S.S. Adams] will likely and unerringly score a direct hit on your dormant childhood consciousness."[36] S.S. Adams and Louis Glackens became entwined when Adams hired Glackens as the company's graphic designer. Glackens' drawings of shocked and startled adults helped to sell the dream of these magical pranks to kids across the country, where they would be eyed on display racks and in the briefcases of traveling

Fig. 3.12 *When Knights Were Bold*, June 19, 1915
J. R. Bray Studios
Digitized 28 mm black-and-white silent film
9 minutes
The G. William Jones Film and Video Collection, Hamon Arts Library, Southern Methodist University

salesmen. Glackens' simple yet comically expressive imagery became integral to S.S. Adams identity and can still be seen among their packaging to this day (fig. 3.13).

Beyond his professional and familial duties, Louis Glackens devoted his time to being an intrepid traveler, and was among the early members of the Circumnavigators Club. The organization (founded in 1902) remains dedicated to individuals that, within a single journey, have traveled a distance exceeding the length of the equator while moving in one direction, starting and finishing at the same point. How a citizen like Glackens managed this accomplishment, particularly in the time before commercial air travel, is astounding. In addition to Glackens, the group also included famous figures such as Harry Houdini and Glackens' muse, President William Howard Taft. Glackens served as one of the art editors for the club magazine *The Log*, lending his artistry to a 1917 cover (fig. 3.14). Despite its ambition of worldliness, Glackens' cover (along with much of the interior content of *The Log*) reflects the xenophobic and racist ideologies of the time.

In the 1917 issue, Circumglackens (as he was known to other members) gives an account of a recent train journey from Grand Central to Montreal for a tour and meet-up with the Canadian Circumnavigators Club branch. While the story is of limited interest, it is accompanied by a photograph of the group, in which Louis Glackens appears to resemble one of his own caricatures. Standing at the far left of the bottom row, his strikingly short stature is revealed. While the other Circums all face the camera with formal acknowledgement, Louis' gaze is caught by something beyond view. As he looks off, his hands are engaged, potentially striking a match to attend to the remnants of

Fig. 3.13 S.S. Adams Company, Asbury Park/Neptune Township, NJ
Mustache, 1950s
Gift of the Friends of the New Jersey State Museum, Cultural History Contingency Fund
Courtesy of New Jersey State Museum. CH2015.6.8

Fig. 3.14 *The Log of the Circumnavigators Club*, 1917
vol. 6, no. 6 (cover)
Photomechanical offset color print in bound hardback
Richard Samuel West Collection

Fig. 3.15 Louis Glackens
(bottom row, left) with the
Circumnavigators Club,
Place Viger Hotel, Montreal,
May 19, 1907
Reproduced in *The Log*,
July–August 1917
Richard Samuel West Collection

the cigar he is smoking (fig. 3.15). The image encapsulates the ways of this anachronistic misfit, a Peter Pan who was born too soon. Nevertheless, his graphic skill, combined with his ability to concoct childlike fantasies with an edge of sharp cynicism, have stood the testament of time. Though his legacy may have been eclipsed, his carnival-like mirroring of society still elicits mirthful laughter.

[1] The accuracy of these dates can only be based on Glackens' signed published work.
[2] For a comprehensive history of *Puck*, see Michael Alexander Kahn and Richard Samuel West, *What Fools These Mortals Be!: The Story of Puck – America's First and Most Influential Magazine of Color Political Cartoons* (San Diego: IDW Publishing, 2014).
[3] Ira Glackens, *Ira on Ira: A Memoir* (New York: Tenth Avenue Editions, distr. Writers and Readers Publishing, 1992), p. 11.
[4] "He freelanced, illustrated a few books, and made animated cartoons for the movies, possibly the first to do so. Here is where Lou could have become a millionaire, except that he was born too soon." Ira Glackens, *William Glackens and The Eight: The Artists Who Freed American Art* (New York: Tenth Avenue Editions, distr. Writers and Readers Publishing, 1990), p. 49.
[5] This first comprehensive survey of Louis M. Glackens' has been confronted with several unverifiable facts, beginning with the artist's birth year. According to the Glackens family tombstone and a letter written January 31, 1974, from Louis Glackens' nephew, Ira Glackens, to catalogue contributor Richard Samuel West, the Glackens family (though uncertain) believed Louis was born in 1867. However, according to his *New York Times* and *New York Herald Tribune* obituaries (printed September 12, 1933), Louis' birth date was May 4, 1866. To further this ambiguity, Louis Glackens' New York State Death Certificate lists his birth year as, "abt 1866." We have therefore resolved to list Louis Glackens' birth year as 1866. Additional undetermined matters will be cited accordingly throughout this publication.
[6] Ira Glackens, *Ira on Ira*, p. 49.
[7] Ira Glackens, *William Glackens and The Eight*, p. 9.
[8] Ira Glackens to Richard Samuel West, February 10, 1974.
[9] Ibid.
[10] "Notable Alumni," *Central High School, School District of Philadelphia*, https://centralhs.philasd.org/about-central-high-school/famous-alumni/, accessed June 4, 2024.
[11] Pennsylvania Academy of the Fine Arts records, 1805–1976. Archives of American Art, Smithsonian Institution.
[12] Art Students League records, 1875–1955. Archives of American Art, Smithsonian Institution.
[13] Louis Glackens to Edith Dimock Glackens, December 12, 1926.
[14] Ira Glackens to Richard Samuel West, January 31, 1974.
[15] Gerald Jonas, "Horatio Alger Is Dead," *The New York Times*, July 16, 1967, p. 198.
[16] Hudor Genone (William James Roe), *The Last Tenet Imposed Upon the Khan of Tomathoz*, illustrated by Louis M. Glackens (Chicago: Charles H. Kerr and Company, 1892), p. 8.
[17] In the game of six degrees of separation, in which the Glackenses were often closely linked to historic figures, Cornelius Vanderbilt's home in West Hartford, CT, was the childhood home of Edith

Dimock Glackens, beloved sister-in-law of Louis Glackens. Edith's father, Ira Dimock, was a highly successful silk manufacturer, who purchased the estate from the Vanderbilt family after Cornelius' suicide. See Glackens, *Ira on Ira*, p. 16.

[18] Kahn and West, *What Fools These Mortals Be!*, p. 15.

[19] The *Puck* Building was designed for the magazine and partnering printer J. Ottmann Lithographing Co., by German American architect Albert Wagner and erected in 1885–86. In a startling paradox that would be all too fitting in the pages of *Puck*, the building is now owned by former and future President Donald J. Trump's Senior Advisor and son-in-law Jared Kushner's family conglomerate, Kushner Companies. Fortunately, the company has kept the gilded statue of *Puck*'s eponymous mascot, designed by sculptor Henry Baerer, in place. Standing sentinel on the corner of Manhattan's Mulberry and Houston Street, Puck continues to watch over the world's mortal follies.

[20] Doris Kearns Goodwin, *The Bully Pulpit: Theodore Roosevelt, William Howard Taft, and the Golden Age of Journalism* (New York: Simon & Schuster, 2013), p. XIV.

[21] "Personal Mention," *The Philadelphia Inquirer*, July 7, 1900, p. 9.

[22] Tom Culbertson, "The Golden Age of American Political Cartoons," *The Journal of the Gilded Age and Progressive Era* 7, no. 3 (July 2008), p. 277.

[23] Kahn and West, *What Fools These Mortals Be!*, p. 13.

[24] Leroy V. Eid, "Puck Depicts the American West," *Arizona and the West* 19, no. 4 (Winter 1977), p. 350.

[25] Ibid.

[26] Ira Glackens, *William Glackens and The Eight*, p. 11.

[27] Louis Glackens to Lenna Glackens, December 6, 1929.

[28] Ibid.

[29] Ira Glackens, *William Glackens and The Eight*, p. 10.

[30] Ira Glackens, *Ira on Ira*, p. 49.

[31] David Hulfish quoted in Amir Ameri, "Placements: The Other Spaces of Cinema," *The Journal of Aesthetics and Art Criticism: Philosophical Investigations into the Art of Building* (Winter 2011), p. 84.

[32] See Louis Glackens' cartoons compiled by the Bray Animation Project, https://brayanimation.weebly.com/l-m-glackens.html, accessed June 10, 2024.

[33] *When Knights Were Bold*, directed by Louis M. Glackens (New York: J. R. Bray Studios, 1915), 28 mm film.

[34] L. M. Glackens Cartoons – Bray Animation Project, https://brayanimation.weebly.com/l-m-glackens.html, accessed June 10, 2024.

[35] Chris Ware, "Foreword," in Kirk Demarais, *Life of the Party: A Visual History of the S.S. Adams Company – Makers of Pranks & Magic for 100 Years* (Woodbury NJ: S.S. Adams LLC, 2006), p. 69.

[36] Ibid., p. 8.

"What Fools These Mortals Be!" Glackens on *Puck*

Richard Samuel West

The year was 1893 and the eyes of the world were on Chicago. The commercial and cultural capital of the Midwest had been selected as the site for a fair to celebrate the 400th anniversary of Columbus' voyage to the Americas. Initially slated for 1892, the city could not complete the fairgrounds in time, so the festivities were pushed back a year. It's no wonder that the opening was delayed. The buildings to house the exhibits to celebrate four centuries of progress were massive: 14 main buildings encompassing 63 million square feet and more than 200 others encompassing millions more. One of those 200 others was the *Puck* Building, a dainty edifice adorned with frosting-like flourishes, nestled between and dwarfed by the Woman's Building and the Horticultural Building and fronting on the central lagoon. *Puck* was a participant in the fair because it was the nation's leading humor magazine and expert in the art of chromolithography. Back in 1876, *Puck* was the first weekly magazine in America to feature mechanical color printing. Since then, the magazine had become a powerhouse politically and financially. Everyone knew *Puck*.

The magazine was the brainchild of three men: Joseph Keppler, a Vienna-born cartoonist, Adolph Schwarzmann, a German American printer, and Henry Cuyler Bunner, a native New York writer. The three created an irrepressible publication, colorful—due to its lithographic front and back covers and centerspread—and witty. By the early 1880s, it was an established financial success and an important magazine of liberal political opinion. Keppler was the frontman of the operation, drawing, in the beginning, all three lithographed cartoons that gave *Puck* its distinctive identity. Soon, *Puck* could afford to hire other cartoonists to assist Keppler, first James A. Wales, then Frederick Burr Opper and Bernhard Gillam. By 1893, Keppler and Opper were still around, but Wales was dead and Gillam had bolted to *Judge*, *Puck*'s conservative competitor. Charles Jay Taylor, Louis Dalrymple, Franklin Morris Howarth, and Keppler's son, Udo, had taken their places.

When *Puck* decided to publish a World's Fair edition in Chicago, Keppler volunteered to man the operation. Opper went too, along with new hires William Allen Rogers, long-time cartoonist for *Harper's Weekly*, and

Fig. 4.1 *World's Columbian Exposition Puck Postcard*, 1893
Printed by J. Ottmann Lithographing Company
NSU Art Museum Fort Lauderdale; William Glackens Archives Collection, GA.2024.17

Frank Hutchins, a young New Jersey native. The World's Fair *Puck* Building was designed so that visitors could enter the front doors and look down over railings into the basement to watch the magazine being printed. The main floor housed the studios of the editors and artists, as well as their sleeping quarters. Inevitably, curious fairgoers wandered uninvited into the studios to watch the men at work, like so many monkeys. Come summer, the heat became oppressive, and nerves frayed. Despite all obstacles the bright little *World's Fair Puck* magazine came out on time every week. But the beleaguered staff paid a heavy price and Keppler couldn't take the strain. In early August he notified Schwarzmann in New York that he was coming home.

Meanwhile, Louis M. Glackens was slowly making his way into the cartooning profession. He got his start with a job at Frank A. Munsey's publishing house. Munsey later became a wealthy titan of journalism, but in 1890 he was a struggling 35-year-old entrepreneur with just two magazines. The first, *The Argosy*, founded in 1882, was a modestly successful children's magazine. The second, *Munsey's Weekly*, founded in 1889, was an anemic imitation of the old comic *Life* magazine. Glackens was put to work immediately, illustrating juvenile serials for *The Argosy* and contributing several cartoons a week to *Munsey's*. Although he was new to the New York commercial art scene, Glackens was, from the first, a mature artist, just as talented as his more seasoned colleagues.

In August 1893, with Keppler coming home, *Puck*'s management surveyed the field of up-and-coming cartoonists and offered Glackens a job in Chicago. Glackens did not hesitate to accept. To advance from a couple of second-tier magazines to the leading humor periodical in America was quite a leap. Additionally, the prospect of working with giants like Keppler and Opper must have been a dream come true.

On Wednesday, August 23, 1893, Glackens' work debuted in the New York *Puck*, a two-panel gag about hoboes. The following Monday, the 28th, his work graced the back cover of the *World's Fair Puck*. At the age of 27, Louis Glackens had arrived. For the next twenty-plus years,

WORLD'S FAIR PUCK

HE LOOKED IT.

JOASH GRAYNECK *(in the museum).*—Say! Did you ever have the dropsy?
LIVING SKELETON.—No. What makes you ask such a foolish question as that?
JOASH.—Oh, nuthin'; only I thought if you'd *had* the dropsy, you was the best cured man that ever I seen.

Fig. 4.2 "He Looked It"
World's Fair Puck, August 28, 1893 (back cover)
Keppler & Schwarzmann, Chicago
Richard Samuel West Collection

he would direct all of his artistic energies into the pages of *Puck*, in the process becoming one of the magazine's longest-tenured artists.

Glackens' first *World's Fair Puck* cartoon was well drawn and designed, but it was a lame joke about a World's Fair visitor in conversation with the "Living Skeleton," a painfully thin man exhibited on the Midway (fig. 4.2). Each of the remaining nine issues of *World's Fair Puck* featured Glackens fair-themed pen-and-inks. He also contributed a chromolithograph to the October 2 cover.

At the same time, in September and October, he contributed one or two pen-and-inks to nearly every issue of the New York-based *Puck*. When he and the rest of the Chicago team returned to Manhattan in November, his drawings continued to appear. Then, inexplicably,

Glackens' career on the magazine stalled. When Wales joined Keppler in the art department in 1879, he was immediately engaged in drawing the color lithographs as well as interior pen-and-inks. The same thing happened when Opper joined *Puck* in 1880 and Gillam in 1881. Keppler, as chief artist, could have hogged the best exposure for himself, but he did not. *Puck* became a veritable academy of lithography for a host of artists. A few, such as Eugene Zimmerman, who came to *Puck* in 1883, were deemed too inexperienced to draw lithographed covers immediately, but by late 1884, he too was given his share of color work. Other artists followed: Louis Dalrymple, Charles Jay Taylor, Franklin Morris Howarth, Samuel D. Ehrhart, Syd B. Griffin, and more. All served a brief apprenticeship and were then granted exposure drawing the coveted color cartoons.

This did not happen to Glackens. For reasons unknown, he languished on *Puck*'s back bench for nearly eight years, drawing his first back cover for the January 2, 1901 issue. That said, he was not idle. His pen-and-ink cartoons appeared week in and week out and he assisted the other

Fig. 4.3 *Puck's Quarterly*, no. 35, October 1904
Photomechanical offset color print
Richard Samuel West Collection

Fig. 4.4 *Pickings from Puck*, no. 57, September 1905
Photomechanical offset color print
Richard Samuel West Collection

Fig. 4.5 "Easter," April 19, 1905
Puck, vol. 57, no. 1468 (cover)
Photomechanical offset color print
Richard Samuel West Collection

Fig. 4.6 "Thanksgiving 1904,"
November 23, 1904
Puck, vol. 59, no. 1447 (cover)
Photomechanical offset color print
Richard Samuel West Collection

artists doing behind-the-scenes tasks, such as coloring the lithographic stones. Later in the period he was also employed creating cover art for *Puck*'s spin-off publications. His first was a *Puck's Library* cover for the September 1899 issue, covers for *Pickings from Puck* and *Puck's Quarterly* soon followed (figs. 4.3, 4.4). Also in that year, he began a long-running series of cartoons under the title *In New Amsterdam*, which became, for a while, his identity in the magazine. The cartoons were set in the era when the Dutch ruled the city and quaint manners and customs dominated daily life.

By the turn of the century, much had changed at *Puck*. Keppler never recovered from the strain induced by his work at the World's Fair and he died in 1894. Bunner, *Puck*'s editor, died two years later. On the art staff, Rogers had returned to *Harper's Weekly*, Hutchins had died (1896), Opper jumped ship for the Hearst papers and Taylor opted for a freelancer's existence. In the meantime, J. S. Pughe and Frank A. Nankivell joined the staff, and Harrison Fisher passed through. Rose O'Neill, Dalrymple, and Howarth would all be the next to depart. That left

PUCK

I.
"Being Dutch, I'm no chaf-what's-his-name," said Dackel to the three;
"If I could n't run an auto, though, I'd lay me down and dee.

II.
"We are going backward, say you? What diff'rence does it make?
Do not bother me with trifles, or I'll give you all the shake.

III.
"And they never even warned me we were coming to a stone;
Well, they've got their shake," quoth Dackel; "now I'll run the thing alone.

IV.
"Bah! There's nothing to this motoring. It's simple as can be—
Wo-Wow! I do believe that tree is steering straight for me!

V.
"I knew it was!" he shouted, as he rose above the crash;
"There was something seemed to tell me we were going to have a smash."

VI.
"You are looking poorly, Dackel," Hans remarked, "you need some fun;
Bring those pieces home, and bring them"— here he chuckled — "one by one."

HANS AND HIS CHUMS.

No. 34.

52

Udo Keppler (who signed his work Keppler Jr. after his father's death), Ehrhart from the pre-1893 staff, and the relative newcomers: Glackens, Pughe, and Nankivell. In the next dozen years, other artists would come and go, but these four were the magazine's mainstays. Management finally woke up to Glackens' potential and for the next thirteen years his graceful line was at the forefront of *Puck*'s endeavors.

In the aught years, Glackens drew nearly all the covers for *Puck*'s secondary publications and for *Puck*'s special holiday issues (figs. 4.5, 4.6). From August 1903 to December 1904, he contributed a comic strip, a spin-off of his *In New Amsterdam* series entitled, "Hans and his Chums" (fig. 4.7). It chronicled the gentle, comical antics of a little Dutch boy and his four dachshunds. Apparently, the strip was popular: it ran for nearly fifty episodes, some of which even graced the color back covers.

In 1905, Glackens engaged in a little side work with *Puck*'s associate editor, Bert Leston Taylor and art editor, W. C. Gibson. The three collaborated on a temperance satire entitled, *The Log of the Water Wagon, or, The Cruise of the Good Ship "Lithia"* (fig. 4.8) with Glackens supplying the art. The charming little volume prompted a sequel the following year, *Extra Dry: Being Further Adventures of the Water Wagon* (1906). Glackens seemed to be a natural illustrator for books with a light touch, yet he had illustrated only one book before joining *Puck* and would illustrate only one more after leaving.

Fig. 4.7 "Hans and his Chums," 1904
Puck, vol. 55, no. 1414, April 6, 1904 (back cover)
Color lithograph on paper
Richard Samuel West Collection

Fig. 4.8 *The Log of the Water Wagon, or, The Cruise of the Good Ship "Lithia,"* 1905
Written by Bert Leston Taylor and W. C. Gibson, illustrated by Louis M. Glackens (New York and Boston: H.M. Caldwell Co., 1905)
NSU Art Museum Fort Lauderdale; William Glackens Archives Collection, GA.2024.2

Glackens' first political cartoon for *Puck* appeared on the back cover of the September 13, 1905 issue. Entitled, "The Senate That Trusts Build" (fig. 4.9), it was an illustrated parody of the nursery rhyme "This Is the House that Jack Built," with Speaker of the House Joseph Cannon cast as the ringleader villain. Glackens' first political centerspread appeared in the July 4, 1906 issue (fig. 4.11). It ridiculed the Chicago meatpackers who claimed before Congress that they did everything they could for the comfort and health of the animals they slaughtered. Like *Puck*'s management, Glackens' political cartoons showed a distrust of Teddy Roosevelt, who advocated for free trade, excoriated the limitless greed of the Trusts, opposed government ownership and ridiculed New York's leading prude, Anthony Comstock. They made fun of William Randolph Hearst's political ambitions, showed an equal dislike of William Jennings Bryan and Taft, and finally, entered into a love affair with the Democratic Party's rising star and 1912 candidate for the presidency, Woodrow Wilson. It would be a mistake, however, to assume that every political cartoon Glackens drew for *Puck* reflected his personal views; he was a *Puck* employee, and he drew what needed to be drawn. On the other hand, it is unlikely

Fig. 4.9 "The Senate That Trusts Build," September 13, 1905
Puck, vol. 58, no. 1504 (back cover)
Lithograph on paper
Richard Samuel West Collection

Fig. 4.10 "Back from Bololand," September 27, 1905
Puck, vol. 58, no. 1491 (cover)
Photomechanical offset color print

Fig. 4.11 "The Real Packingtown – If You Let the Packers Tell It," July 4, 1906
Puck, vol. 59, no. 1531 (centerfold)
Photomechanical offset color print

that the management ever commanded him to draw a cartoon oppositional to his own political views. Certainly, *Puck*'s left-leaning politics appealed to Lou's brother William; they likely appealed to Lou as well.

How did Glackens' work compare to his contemporaries? Some had funnier styles, particularly Opper and Zimmerman. And many drew more powerfully, like (Udo) Keppler Jr. and Arthur Young. While accurate and cartoony, his caricatures lacked distinctiveness and failed to further the point of the cartoon, but Glackens was a draftsman of the first order. Few could match his lovely, fluid line. His work never appeared labored. It seemed to just flow naturally from his pen. So, though Glackens did not rank among the era's great cartoonists, he was great at what he did.

By 1914, *Puck* had become a footnote on the American scene. Its circulation had shrunk to 15,000, a tenth of what it had been in its glory days. By that time, not all advertisers wanted to be associated with *Puck*'s left-leaning politics. Moreover, *Puck*'s 16-page format did not lend itself to many of the full-page advertisements businesses

Theatre Designed for the "Tired Business Man"

A right woman can make a fool of any man, but if he is the right man she won't.

It isn't that married men are really any worse than bachelors—they have press agents, that's all.

The rich eat sandwiches tied with ribbon. And the poor get bread tied up with red tape.

increasingly preferred. Keppler Jr. and Schwarzmann decided to sell out. *Puck*'s new owner was Nathan Straus Jr., son of the department store magnate. He had visions of turning *Puck* into an elegant American version of the highbrow humor magazines of Europe, particularly France's *L'Assiette au beurre* (The Butter Plate) and Germany's *Simplicissimus*.

Although Nathan Straus Jr. continued to employ Keppler Jr., along with Glackens and some other holdovers from the old regime, none of them had a permanent place in his new vision. Glackens' last cartoon for *Puck* appeared in the May 9, 1914 issue, the week of his 48th birthday (fig. 4.12). Despite having a mountain of beautiful work to show for his twenty-plus years on *Puck*, Glackens had no place to go. During the 1910s and '20s, most comic artists found berths in newspaper art departments, or migrated to the new form of animation. No one seemed more suited to either than Glackens with his simple expressive figures, but for some reason, even though he tried both, neither ended up working for him. It could have been that Glackens enjoyed a long and successful second career, but it was not to be.

Fig. 4.12 "Theatre Designed for the 'Tired Business Man'," 1914
Puck, vol. 75, no. 1940,
May 9, 1914 (interior page)
Photomechanical offset print
Richard Samuel West Collection

Pl. 8 *In Colonial Days*, c. 1905
Lithograph on paper
8.5 × 11 in. (21.5 × 27.9 cm)
Richard Samuel West Collection

Pl. 9 "JUST SUPPOSE. Lawyer Hetty – Is that another of those crazy Man's Rights cranks? Commissioner Gladys – Yes, that's Anthony B. Susan. He doesn't dare argue with a full grown woman, but he picks out a little one like Alderman Gertie, and talks her to death," 1905
Puck, October 11, 1905
Ink on illustration board
12.3 × 16.3 in. (31.3 × 41.3 cm)
Delaware Art Museum, gift of Helen Farr Sloan, 1978

Pl. 10 "The Great American Traveler," September 25, 1907
Puck, vol. 62, no. 1595 (cover)
Photomechanical offset color print

In Glackens' imagining of William Howard Taft's extended sojourn across the Asian Pacific, he depicts the then-Secretary of War's postcards home to President Roosevelt, sending his best from the wonders of Egypt, Japan, Russia, the Philippines, Tahiti, Burma, and the Solomon Islands. The imagery is laden with racist caricatures that invoke the history of colonization, in which the enslavement and exploitation of non-Europeans extended to their treatment as spectacle for public consumption.

PUCK

GREAT AMERICAN TRAVELER.
despair).—I might have known that Bill would get the habit.

Pl. 11 "Here, Puss, Puss!"
August 5, 1908
Puck, vol. 64, no. 1640 (cover)
Photomechanical offset color print
NSU Art Museum Fort Lauderdale; William Glackens Archives Collection, GA.2024.6

This satiric scene depicts a pinafored Secretary of State and Democratic presidential candidate, William Jennings Bryan, coaxing the "Labor Vote" cat, whose face depicts labor union leader Samuel Gompers, with a bowl of "Anti-Injunction Cream." Simultaneously, a sweetly dressed presidential candidate, William Howard Taft, proffers his alternative, some "Anti-Injunction Catnip." Together, the little children compete for attention with dully comparable offerings in a bid to win Gompers' electoral support.

Following pages

Pl. 12 "The Marathon Mania,"
January 20, 1909
Puck, vol. 64, no. 1664 (centerfold)
Photomechanical offset color print
NSU Art Museum Fort Lauderdale; William Glackens Archives Collection, GA.2024.8

Glackens humorously conflates the growing craze around marathons at the turn of the century with the classic metaphor, "the race of life." In *Puck*'s version of the game, the cost of living always beats the middle- and working-class chasers of the American Dream. At the center of this rat race is a consumer shackled to a corrupt "graft tariff," chasing after a mocking figure comprised of home goods. At the bottom right, the outgoing Vice President Charles W. Fairbanks (1852–1918) is beaten to the finish line by the shrouded figure of oblivion, killing his hopes for political prominence in the future. Nevertheless, for the bridge whist players of high society, the marathon is not quite so dreaded. At 300 laps to the mile, the race is both absurd and unchallenging.

Puck

VOL. LXIV. No. 1640. PUCK BUILDING, New York, August 5th, 1908. PRICE TEN CENTS.

"What Fools these Mortals be!"

"HERE, PUSS, PUSS!"

I love little pussy,
 His coat is so warm,
And if I don't hurt him,
 He'll do me no harm.

So I'll not pull his tail,
 Or drive him away;
But pussy and I
 Very gently will play.

The Suburban Marathon.

The Vice-Presidential Marathon—Oblivion Wins!

Pl. 13 "The Rousing of Rip," 1909
Puck, March 24, 1909
Ink and blue pencil on illustration board
16.8 × 12.4 in. (42.5 × 31.4 cm)
Delaware Art Museum, gift of Helen Farr Sloan, 1978

Pl. 14 "No More of That, Thank You. I'm Awake," March 24, 1909
Puck, vol. 65, no. 1673 (cover)
Photomechanical offset color print

Pl. 15 "Shadrach, Meshach, and Abednego," May 19, 1909
Puck, vol. 65, no. 1681 (cover)
Photomechanical offset color print
NSU Art Museum Fort Lauderdale; William Glackens Archives Collection GA.2024.9

Standing in place of the three believers from the Book of Daniel is a triumvirate of monopoly men representing the industries of clothing, building material, and food. They walk into the flames of tariff revision with both beatific and malevolent expressions.

As Americans debated between the protection of domestic industries and the need for lower consumer prices, powerful corporations faced the fiery risk of cost hikes. Without the holy faith that protected Shadrach, Meshach, and Abednego, it seems that these corporate figures are unlikely to withstand the threat of capitalist reform.

SHADRACH, MESHACH, AND ABEDNEGO.
WILL THE HISTORY OF THE FIERY FURNACE REPEAT ITSELF?

Pl. 16 "Independence Day at Last," 1910
Puck, June 29, 1910
Black-and-white printer's proof
Richard Samuel West Collection

Pl. 17 "Independence
Day at Last," 1910
Puck, June 29, 1910
Printer's proof with hand-coloring
by Louis Glackens
for printer's guide
Richard Samuel West Collection

Pl. 18 "Who Are You?"
July 28, 1909
Puck, vol. 66, no. 1691 (cover)
Photomechanical offset color print
NSU Art Museum Fort Lauderdale;
William Glackens Archives
Collection GA.2024.10

A Democratic donkey and Republican elephant glare down at a trembling Consumers Party goat. Nestled away in their stable of the traditional political system, this everyman intruder (though far less powerful) threatens to disrupt the comforts of the two-party establishment. In the face of new movements such as the Socialist Party, Populist Movement, Prohibition and Labor, members of major parties were made to decide whether to adapt or attack in the face of these rising factions.

Following pages

Pl. 19 "The Invasion of England,"
August 18, 1909
Puck, vol. 66, no. 1694 (centerfold)
Photomechanical offset color print
William Chrisant & Sons' Old
Florida Book Shop, Fort Lauderdale

THE INVASI
FROM THE SECRET ARCH

ENGLAND.
GERMAN WAR OFFICE.

Pl. 20 "No Limit,"
September 22, 1909
Puck, vol. 66, no. 1699 (cover)
Photomechanical offset color print
NSU Art Museum Fort Lauderdale;
William Glackens Archives
Collection GA.2024.11

A high stakes poker game is depicted between Kaiser Wilhelm II (1859–1941), Edward VII, King of the British Empire (1841–1910), French President Armand Fallières (1841–1931), Emperor Meiji of Japan (1852–1912), and Uncle Sam. Meiji holds up a battleship, raising the stakes of the game. As these international leaders vie for imperial dominance of the seas, there seems to be *No Limit* in this naval arms race, an early twentieth-century global phenomenon that radically impacted international relations and set the stage for the World Wars.

Following pages

Pl. 21 "In the Republican Dark-Room," March 2, 1910
Puck, vol. 67, no. 1722 (cover)
Photomechanical offset color print

Pl. 22 "The Heavenly Porter,"
May 18, 1910
Puck, vol. 67, no. 1733 (cover)
Photomechanical offset color print

IN THE REPUBLICAN DARK-ROOM.
AN AMATEUR PHOTOGRAPHER WHO SPOILS GOOD PLATES BY USING BAD CHEMICALS.

Pl. 23 "The Convention Spring at Saratoga," September 21, 1910
Puck, vol. 68, no. 1751 (cover)
Photomechanical offset color print
NSU Art Museum Fort Lauderdale;
William Glackens Archives
Collection GA.2024.12

In the lead up to the Saratoga Springs, New York political conventions, "A Clean-Cut Progressive Platform" is seen gushing from a "Medicinal Spring" with Theodore Roosevelt's face carved into it. Republican politicians J. S. Sherman, Timothy Woodruff, James W. Wadsworth and William Barnes Jr. stand around looking apprehensively into their water glasses. As the former president's stone shadow continues to bring forth ideas of reform, these members of the establishment seem uncertain of their offerings.

Following pages

Pl. 24 "The Yellow Press,"
October 12, 1910
Puck, vol. 68, no. 1754 (centerfold)
Photomechanical offset color print
William Chrisant & Sons'
Old Florida Book Shop,
Fort Lauderdale

Pl. 25 "Young America and the Moving-Picture Show,"
November 9, 1910
Puck, vol. 68, no. 1758 (cover)
Photomechanical offset color print

THE CONVENTION SPRING AT SARATOGA.
You Can Lead Them to the Waters, But Can You Make Them Drink?

"The time is at hand when these journalistic scoundrels have got to stop or get out, and I am ready now to do my share to that end. They are absolutely without souls. If decent people would refuse to look at such newspapers the thing would right itself at once. The journalism of New York City has been dragged to the lowest depths of degradation. The grossest railleries and libels, instead of honest statements and fair discussion, have gone on unchecked."
—*From Mayor Gaynor's Letter published in the New York Evening Post.*

THE Y
THOSE WHO FEED

PRESS.
 Whom it Feeds.

THE GUIDE POST

SUNDAY SCHOOL

THOU SHALT NOT STEAL

THE DEVIL'S RECRUITING STATION

THE PUCK PRESS

FROM THE SUNDAY-SCHOOL TO THE —

YOUNG AMERICA AND

— MOVING-PICTURE SHOW IS BUT A STEP.

HEAVEN, ACCORDING TO THE MOVING PICTURE MAN

Films for to day THE SAFE-CRACKERS A GREAT REALISTIC SENSATIONAL FILM

"WHERE DID YOU LEARN TO BREAK A SAFE?" "AT DE MOVING PICTURE SHOW" BOY.

MOVING-PICTURE SHOW.

Pl. 26 *Puck July 4th Cover Art* ("The Rich Child's Fourth"), June 28, 1911
Ink on paper
20 × 14.2 in. (51 × 36 cm)
The Ohio State University Billy Ireland Cartoon Library & Museum

A gruff man is seen gesturing towards an exploding battleship that lights up the horizon. A young boy—silhouetted by the orange blast—is seen jumping with excitement. The caption informs us that this is a rich man's version of the 4th of July, in which a $20,000 ship is destroyed in lieu of fireworks as a reward for good behavior. Once again, through Glackens, *Puck* shows its contempt for the grotesquely wealthy elite, whose extravagant spectacles epitomize their wasteful and destructive habits.

Following pages

Pl. 27 *Puck Harvest Number* ("From Summer Boarders"), August 23, 1911
Ink and blue pencil on paper
20.3 × 15.7 in. (51.7 × 39.8 cm)
International Museum of Cartoon Art Collection and Records, The Ohio State University Billy Ireland Cartoon Library & Museum

Pl. 28 "From Summer Boarders – Harvest Number," September 6, 1911
Puck, vol. 70, no. 1801 (cover)
Photomechanical offset color print

A group of countryfolk dance around a corn shock with tassels of cash, tied together with a ribbon that reads "From Summer Boarders." As early twentieth century ushered in industrial urbanization, leading people to seek jobs in inner cities, rural America became a place of refuge. For workers looking for a brief escape from the chaos and pollution of the city, the little extra cash from their new industry jobs could be spent on a relaxing summertime rental in the picturesque lake and mountain regions of New England and the Midwest.

Pl. 29 "The Judgment of Solomon Taft," November 29, 1911
Puck, vol. 70, no. 1813 (cover)
Photomechanical offset color print
NSU Art Museum Fort Lauderdale; William Glackens Archives Collection GA.2024.14

President Taft is depicted as the biblical King Solomon, known for his wisdom. He dangles the G.O.P. elephant, preparing to split it in half, while two men labelled "Stand-Patter" (representative of the conservatives) and "Insurgent" (the reformists) look on, pleading for mercy. The cartoon captures the tension within the Republican Party at this time, reflecting the challenges faced by Taft in his attempt to unite a party torn between competing ideologies and interests.

Following pages

Pl. 30 *Happy New Year Votes for Women (Puck)*, December 27, 1911
Pencil, wash, board
17.9 × 13.9 in. (45.4 × 35.2 cm)
International Museum of Cartoon Art Collection and Records, The Ohio State University Billy Ireland Cartoon Library & Museum

Pl. 31 "Look Who's Here!"
December 27, 1911
Puck, vol. 70, no. 1817 (cover)
Photomechanical offset color print

THE JUDGMENT OF SOLOMON TAFT.

93

Pl. 32 "Johnny's Noah's Ark. Being a Regular Attendant at Sunday School, He at once Proceeds to Enact the Flood," 1911
Puck, December 6, 1911 (interior page)
Commercial lithograph with hand-coloring
14.2 × 11.3 in. (36.2 × 28.7 cm)
Delaware Art Museum, gift of Helen Farr Sloan, 1978

Following pages

Pl. 33 "Beg for It, Doggie!"
March 13, 1912
Puck, vol. 71, no. 1828 (cover)
Photomechanical offset color print

Pl. 34 "The Flowers that Bloom in the Spring, tra-la!" April 24, 1912
Puck, vol. 71, no. 1834 (cover)
Photomechanical offset color print
NSU Art Museum Fort Lauderdale; William Glackens Archives Collection GA.2024.13

This pastoral scene depicts a President Taft wielding a watering can labeled "Patronage," which he pours over a bed of flowers labeled "Delegates: Hardy Quadrennial," symbolizing the politicians from which he hopes to cultivate robust support of his re-election campaign. The irony of this softhearted scene is pushed further by the caption, a whimsical reference to Gilbert & Sullivan's operetta *The Mikado*.

JOHNNY'S NOAH'S ARK.
BEING A REGULAR ATTENDANT AT SUNDAY-SCHOOL, HE AT ONCE PROCEEDS TO ENACT THE FLOOD.

FROM THE POLKVILLE CLARION.

How happily was exemplified, last Wednesday afternoon, that neither bolts nor bars, as the poet aptly stated, can keep fond hearts asunder, when Miss Elodia Fretta Dismukes became the blushing bride of Claud Waddington Weems at the residence of the groom's parents under the urbane officiation of the Reverend Mr. Busenbark. The course of true love had run smooth for this popular couple until three days before the date set for their nuptials, when the unfortunate young man was stricken with measles. But nothing could daunt the dainty bride-to-be, and at the appointed hour the wedding procession, consisting of relatives and friends who earlier in life had been victims of the malady which had laid the groom low, formed in the front yard, and headed by Miss Dismukes, arrayed in all her festal finery and leaning on the arm of her father, passed into the sickroom, where she and Mr. Weems were made one, while the organ pealed forth "O, Promise Me!" and the bride stood beside the couch of pain and looked down at the sufferer with a pretty air of possession and protection. Love will always find a way! *Tom P. Morgan.*

Love is blind, but the prudent lemon will still continue to wear orange blossoms.

GETTING OFF EASY.

Adam in the Garden of Eden had just named the animals.
"A pretty big job," he announced, "but just think of the fellow who will have to name all the diseases!"
Herewith he pitied his posterity.

HOLIDAY HINT.
USEFUL CHRISTMAS PRESENT FOR ANY ONE ADDICTED TO THE WHISKER HABIT.

DIFFICULTIES

The ghost of the defunct betrayed so uncommon a mixture of uneasiness and reluctance that the curiosity of other wraiths was presently moved.
"Why don't you get busy?" those latter made bold to inquire, at length.
To which the unhappy spirit replied:
"Alas, I was murdered in a flat so replete with articles of *vertu* that when I think of haunting it in the dark, in my bare shins, my courage fails me!"
A hush fell upon the assembly, for while there were those present who had been most foully done to death, none had quite such difficulties to contend with.

ITS LOCATION.

GLADYS ROXTON.— And the Duke is *so* brave, papa! Why, he declares he intends to become an aviator!
PAPA.— H'm! He does, eh? Wants to visit his castle, I suppose?

IN BOSTON.

TEACHER.— Waldo, name one of the best-known characters of fiction.
WALDO *(aged five, superciliously).*— Santa Claus!

Puck

VOL LXXI. No. 1828. PUCK BUILDING, New York, March 13th, 1912. PRICE TEN CENTS.

"BEG FOR IT, DOGGIE!"

VOL. LXXI. No. 1834. PUCK BUILDING, New York, April 24th, 1912. PRICE TEN CENTS.
Copyright, 1912, by Keppler & Schwarzmann. Entered at N. Y. P. O. as Second-class Mail Matter.

PUCK

"THE FLOWERS THAT BLOOM IN THE SPRING, TRA-LA!"

Pl. 35 "Speed! The Terror of the Sea," May 1, 1912
Puck, vol. 71, no. 1835 (cover)
Photomechanical offset color print
NSU Art Museum Fort Lauderdale; William Glackens Archives Collection GA.2024.15

Following pages

Pl. 36 "He Doesn't Realize What is Coming to Him," July 17, 1912
Puck, vol. 71, no. 1846 (cover)
Photomechanical offset color print

Pl. 37 "La Première Danseuse," November 20, 1912
Puck, vol. 72, no. 1864 (cover)
Photomechanical offset color print

VOL. LXXI. No. 1835. PUCK BUILDING, New York, May 1st, 1912. PRICE TEN CENTS.
Copyright, 1912, by Keppler & Schwarzmann. Entered at N.Y.P.O. as Second class Mail Matter.

PUCK

SPEED!
THE TERROR OF THE SEA.

HE DOESN'T REALIZE WHAT IS COMING TO HIM.

THANKSGIVING NUMBER

PUCK BUILDING, New York, November 20th, 1912.

VOL. LXXII. No. 1864. Copyright, 1912, by Keppler & Schwarzmann. Entered at N. Y. P. O. as Second-class Mail Matter. PRICE TEN CENTS.

Puck

What fools these Mortals be
—MIDSUMMER-NIGHT'S DREAM

LA PREMIÈRE DANSEUSE.

Pl. 38 "He Had a Hunch," 1913
Cover for *Puck*, February 19, 1913
Commercial lithograph with hand-coloring
14.3 × 11.3 in. (36.2 × 28.7 cm)
Delaware Art Museum,
gift of Helen Farr Sloan, 1978

Following pages

Pl. 39 "It Would be Worth It,"
August 20, 1913
Puck, vol. 74, no. 1903 (cover)
Photomechanical offset color print

Pl. 40 "When Duty Calls,"
September 24, 1913
Puck, vol. 74, no. 1908 (cover)
Photomechanical offset color print
NSU Art Museum Fort Lauderdale;
William Glackens Archives
Collection GA.2024.16

HE HAD A HUNCH.

GEORGE WASHINGTON.—This is no place for a man who couldn't tell a lie!

VOL. LXXIV. No. 1903.　　PUCK BUILDING, New York, August 20th, 1913.　　PRICE TEN CENTS.
Copyright, 1913, by Keppler & Schwarzmann. Entered at N. Y. P. O. as Second-Class Mail Matter.

Puck

"What fools these Mortals be"
—MIDSUMMER-NIGHT'S DREAM

IT WOULD BE WORTH IT.

VOL. LXXIV. No. 1908. PUCK BUILDING, New York, September 24th, 1913. PRICE TEN CENTS.

Puck

"What Fools these Mortals be."

WHEN DUTY CALLS.
THE SPARTAN MOTHER.—Go, my boy!

Pl. 41 *When Knights Were Bold*,
June 19, 1915
J. R. Bray Studios
Digitized 28 mm black-and-white silent film
9 minutes
The G. William Jones Film and Video Collection, Hamon Arts Library, Southern Methodist University

WHEN KNIGHTS WERE BOLD

Having failed to rouse the monster's Angora, he cunningly places a seductive picnic basket and a bottle of rare old vintage near the family entrance.

PATHE-PUBLISHERS

Pl. 42 *Our Bone Relatives,*
April 1, 1918
J. R. Bray Studios
Digitized 28 mm black-and-white silent film
3 minutes, 6 seconds
George Eastman Museum

Pl. 43 S.S. Adams Company, Asbury Park/Neptune Township, NJ
Black Widow Spider,
c. 1950s
Gift of the Friends of the New Jersey State Museum, Cultural History Contingency Fund
Courtesy of New Jersey State Museum. CH2015.6.4

Pl. 44 S.S. Adams Company, Asbury Park/Neptune Township, NJ
Joy Hand Buzzer, c. 1928
Gift of the Friends of the New Jersey State Museum, Cultural History Contingency Fund
Courtesy of New Jersey State Museum. CH2015.6.1

Pl. 45 S.S. Adams Company, Asbury Park/Neptune Township, NJ
Shooting Lip Stick, c. 1950s
Gift of the Friends of the New Jersey State Museum, Cultural History Contingency Fund
Courtesy of New Jersey State Museum. CH2015.6.9

Pl. 46 S.S. Adams Company, Asbury Park/Neptune Township, NJ
Smokie Cigarettes, c. 1950s
Gift of the Friends of the New Jersey State Museum, Cultural History Contingency Fund
Courtesy of New Jersey State Museum. CH 2015.6.7

Pl. 47 S.S. Adams Company, Asbury Park/Neptune Township, NJ
Dime Store Display Rack Sign, c. 1957

Gift of the Friends of the New Jersey State Museum, Cultural History Contingency Fund
Courtesy of New Jersey State Museum. CH2015.32.1

Following pages

Pl.48 *Hurry up Girls—Here comes the customers*, n.d.
Graphite on paper
17.2 × 21.3 in. (43.6 × 53.9 cm)
NSU Art Museum Fort Lauderdale; bequest of Ira D. Glackens, 91.40.132

Hurry up girls — Here comes
the customers!

49

Pls. 49–58
Louis M. Glackens
Untitled, n.d.
Graphite, colored pencil
on paper
Dimensions variable
NSU Art Museum Fort Lauderdale;
bequest of Ira D. Glackens

50

51

52

FISH, FISH, WHO'S GOT THE FISH?

54

55

56

58

Pl. 59 Photographer unknown Louis Glackens as cowboy (with chaps), Steve Brodie (champion bridge jumper) in bowler hat, man at left unidentified, c. 1900–14
Carte de visite photograph
4.6 × 3.6 in. (11.7 × 9 cm)

NSU Art Museum Fort Lauderdale; William Glackens Archives Collection, ARC2021.658.b

Pl. 60 Photographer unknown
Louis Glackens (left), Frank Hutchins (illustrator for *Puck*, standing), and Steve Brodie (champion bridge jumper, right), c. 1890–1900

Tintype photograph
NSU Art Museum Fort Lauderdale; William Glackens Archives Collection, ARC2021.658.a

Pl. 61 *New Day*, n.d.
Ink and blue pencil on paper
14.2 × 11.4 in. (36 × 29 cm)
Charles H. Kuhn Collection, The
Ohio State University Billy Ireland
Cartoon Library & Museum

Exhibition Checklist

All works by Louis M. Glackens unless noted otherwise

Except otherwise specified, all *Puck* images Courtesy of the Library of Congress, Rare Book and Special Collections Division. Images in the public domain.

Photographer unknown
Portrait of Louis Glackens, c. 1871
Cabinet card
5.6 × 4.1 in. (14.2 × 10.5 cm)
NSU Art Museum Fort Lauderdale; William Glackens Archives Collection, ARC2021.287
Figure 1 p. 6

Phillip Edward Chillman
Portrait of Louis Glackens, c. 1880
Cabinet card
6.5 × 4.3 in. (16.5 × 11 cm)
NSU Art Museum Fort Lauderdale; William Glackens Archives Collection, ARC2021.23.a
Figure 2 p. 9

Photographer unknown
Louis Glackens (left), Frank Hutchins (illustrator for *Puck*, standing), and Steve Brodie (champion bridge jumper, right), c. 1890–1900
Tintype photograph
NSU Art Museum Fort Lauderdale; William Glackens Archives Collection, ARC2021.658.a
Plate 60 p. 129

The Last Tenet Imposed Upon the Khan of Tomathoz
Written by Hudor Genone (pseudonym of William James Roe)
Illustrated by Louis M. Glackens
Published by Charles H. Kerr and Company, Chicago, 1892
NSU Art Museum Fort Lauderdale; William Glackens Archives Collection, GA.2024.3
Figure 3.2 p. 29

Graphic designer unknown
World's Columbian Exposition Puck Postcard, 1893
Color lithograph on paper
Printed by J. Ottmann Lithographing Company
3.5 × 6 in. (8.8 × 15.2 cm)
NSU Art Museum Fort Lauderdale; William Glackens Archives Collection, GA.2024.17
Figure 4.1 p. 46

"He Looked It" August 28, 1893
World's Fair Puck, no.17 (back cover)
Published by Keppler & Schwarzmann, Chicago
10 × 14 in. (25.4 × 35.6 cm)
Richard Samuel West Collection
Figure 4.2 p. 49

Photographer unknown
Louis Glackens as cowboy (with chaps), Steve Brodie (champion bridge jumper) in bowler hat, man at left unidentified, c. 1900–14
Carte de visite photograph
4.6 × 3.6 in. (11.7 × 9 cm)
NSU Art Museum Fort Lauderdale; William Glackens Archives Collection, ARC2021.658.b
Plate 59 p. 128

Three Identical Men in Top Hats with Monocles, 1903
Ink on Bristol board
12.1 × 8.2 in. (30.7 × 20.8 cm)
Delaware Art Museum, gift of Helen Farr Sloan, 1978
Figure 1.1 p. 10

"Hans and his Chums," 1904
Puck, vol. 55, no. 1414, April 6, 1904 (back cover)
Color lithograph on paper
13.2 × 9.3 in. (33.6 × 23.8 cm)
Published by J. Ottmann Lith. Co., Puck Bldg., New York
Richard Samuel West Collection
Figure 4.7 p. 52

"Thanksgiving 1904," November 23, 1904
Puck, vol. 59, no. 1447 (cover)
Photomechanical offset color print
13.5 × 10.5 in. (34 × 27 cm)
Published by J. Ottmann Lith. Co., Puck Bldg., New York
Richard Samuel West Collection
Figure 4.6 p. 51

In Colonial Days, c. 1905
Lithograph on paper
8.5 × 11 in. (21.5 × 27.9 cm)
Richard Samuel West Collection
Plate 8, p. 58

The Log of the Water Wagon, or, The Cruise of the Good Ship "Lithia," 1905
Written by Bert Leston Taylor and W. C. Gibson
Illustrated by Louis M. Glackens
Published by H.M. Caldwell Co., New York and Boston, 1905
NSU Art Museum Fort Lauderdale; William Glackens Archives Collection, GA.2024.2
Figure 4.8 p. 53

"Easter," April 19, 1905
Puck, vol. 57, no. 1468 (cover)
Photomechanical offset color print
13.5 × 10.5 in. (34 × 27 cm)
Published by J. Ottmann Lith. Co., Puck Bldg., New York
Richard Samuel West Collection
Figure 4.5 p. 51

"JUST SUPPOSE. Lawyer Hetty – Is that another of those crazy Man's Rights cranks? Commissioner Gladys – Yes, that's Anthony B. Susan. He doesn't dare argue with a full grown woman, but he picks out a little one like Alderman Gertie, and talks her to death," 1905
Puck, October 11, 1905
Ink on illustration board
12.3 × 16.3 in. (31.3 × 41.3 cm)
Delaware Art Museum, gift of Helen Farr Sloan, 1978
Plate 9 p. 59

"St. Anthony Comstock, the Village Nuisance," August 22, 1906
Puck, vol. 60, no. 1538 (centerfold)
Photomechanical offset color print
13.5 × 21 in. (34 × 53 cm)
Published by J. Ottmann Lith. Co., Puck Bldg., New York
William Chrisant & Sons' Old Florida Book Shop, Fort Lauderdale
Photograph retrieved from the Library of Congress
https://www.loc.gov/item/2011645932/
Figure 2.1 p. 12

"Here, Puss, Puss!" August 5, 1908
Puck, vol. 64, no. 1640 (cover)
Photomechanical offset color print
13.5 × 10.5 in. (34 × 27 cm)
Published by J. Ottmann Lith. Co., Puck Bldg., New York
NSU Art Museum Fort Lauderdale; William Glackens Archives Collection, GA.2024.6
Photograph retrieved from the Library of Congress
https://www.loc.gov/item/2011647329/
Plate 11 p. 63

"The Marathon Mania," January 20, 1909
Puck, vol. 64, no. 1664 (centerfold)
Photomechanical offset color print
13.5 × 21 in. (34 × 53 cm)
Published by J. Ottmann Lith. Co., Puck Bldg., New York
NSU Art Museum Fort Lauderdale; William Glackens Archives Collection, GA.2024.8
Photograph retrieved from the Library of Congress
https://www.loc.gov/item/2011647388/
Plate 12 pp. 64–65

"The Rousing of Rip," 1909
Puck, March 24, 1909
Ink and blue pencil on illustration board
16.8 × 12.4 in. (42.5 × 31.4 cm)
Delaware Art Museum, gift of Helen Farr Sloan, 1978
Plate 13 p. 66

"Shadrach, Meshach, and Abednego," May 19, 1909
Puck, vol. 65, no. 1681 (cover)
Photomechanical offset color print
13.5 × 10.5 in. (34 × 27 cm)
Published by J. Ottmann Lith. Co., Puck Bldg., New York
NSU Art Museum Fort Lauderdale; William Glackens Archives Collection GA.2024.9
Photograph retrieved from the Library of Congress
https://www.loc.gov/item/2011647470/
Plate 15 p. 69

"Who Are You?" July 28, 1909
Puck, vol. 66, no. 1691 (cover)
Photomechanical offset color print
13.5 × 10.5 in. (34 × 27 cm)
Published by J. Ottmann Lith. Co., Puck Bldg., New York
NSU Art Museum Fort Lauderdale; William Glackens Archives Collection GA.2024.10
Photograph retrieved from the Library of Congress
https://www.loc.gov/item/2011647490/
Plate 18 p. 73

"The Invasion of England," August 18, 1909
Puck, vol. 66, no. 1694 (centerfold)
Photomechanical offset color print
13.5 × 21 in. (34 × 53 cm)
Published by J. Ottmann Lith. Co., Puck Bldg., New York
William Chrisant & Sons' Old Florida Book Shop, Fort Lauderdale
Photograph retrieved from the Library of Congress
https://www.loc.gov/item/2011647497/
Plate 19 pp. 74–75

"No Limit," September 22, 1909
Puck, vol. 66, no. 1699 (cover)
Photomechanical offset color print
13.5 × 10.5 in. (34 × 27 cm)
Published by J. Ottmann Lith. Co., Puck Bldg., New York
NSU Art Museum Fort Lauderdale; William Glackens Archives Collection GA.2024.11
Photograph retrieved from the Library of Congress
www.loc.gov/item/2011647506/
Plate 20 p. 77

"Independence Day at Last," 1910
Puck, June 29, 1910
Black-and-white printer's proof
13.5 × 10.5 in. (34 × 27 cm)
Richard Samuel West Collection
Plate 16 p. 70

"Independence Day at Last," 1910
Puck, June 29, 1910
Printer's proof with hand-coloring by Louis Glackens for printer's guide
13.5 × 10.5 in. (34 × 27 cm)
Richard Samuel West Collection
Plate 17 p. 71

"The Convention Spring at Saratoga," September 21, 1910
Puck, vol. 68, no. 1751 (cover)
Photomechanical offset color print
13.5 × 10.5 in. (34 × 27 cm)
Published by J. Ottmann Lith. Co., Puck Bldg., New York
NSU Art Museum Fort Lauderdale; William Glackens Archives Collection GA.2024.12
Photograph retrieved from the Library of Congress
www.loc.gov/item/2011647623/
Plate 23 p. 81

"The Yellow Press," October 12, 1910
Puck, vol. 68, no. 1754 (centerfold)
Photomechanical offset color print
13.5 × 21 in. (34 × 53 cm)
Published by J. Ottmann Lith. Co., Puck Bldg., New York
William Chrisant & Sons' Old Florida Book Shop, Fort Lauderdale
Photograph retrieved from the Library of Congress
https://www.loc.gov/item/2011647630/
Plate 24 pp. 82–83

Puck July 4th Cover Art ("The Rich Child's Fourth"), June 28, 1911
Ink on paper
20 × 14.2 in. (51 × 36 cm)
The Ohio State University Billy Ireland Cartoon Library & Museum
Plate 26 p. 87

Puck Harvest Number ("From Summer Boarders"), August 23, 1911
Ink and blue pencil on paper
20.3 × 15.7 in. (51.7 × 39.8 cm)
International Museum of Cartoon Art Collection and Records,
The Ohio State University Billy Ireland Cartoon Library & Museum
Plate 27 p. 88

"The Judgment of Solomon Taft," November 29, 1911
Puck, vol. 70, no. 1813 (cover)
Photomechanical offset color print
13.5 × 10.5 in. (34 × 27 cm)
Published by J. Ottmann Lith. Co., Puck Bldg., New York
NSU Art Museum Fort Lauderdale; William Glackens Archives Collection GA.2024.14
Photograph retrieved from the Library of Congress
www.loc.gov/item/2011649082/
Plate 29 p. 91

"Johnny's Noah's Ark. Being a Regular Attendant at Sunday School, He at once Proceeds to Enact the Flood," 1911
Puck, December 6, 1911 (interior page)
Commercial lithograph with hand-coloring
14.2 × 11.3 in. (36.2 × 28.7 cm)
Delaware Art Museum, gift of Helen Farr Sloan, 1978
Plate 32 p. 95

Happy New Year Votes for Women (Puck), December 27, 1911
Pencil, wash, board
17.9 × 13.9 in. (45.4 × 35.2 cm)
International Museum of Cartoon Art Collection and Records,
The Ohio State University Billy Ireland Cartoon Library & Museum
Plate 30 p. 92

"The Flowers that Bloom in the Spring, tra-la!" April 24, 1912
Puck, vol. 71, no. 1834 (cover)
Photomechanical offset color print
13.5 × 10.5 in. (34 × 27 cm)
Published by J. Ottmann Lith. Co., Puck Bldg., New York
NSU Art Museum Fort Lauderdale; William Glackens Archives Collection GA.2024.13
Photograph retrieved from the Library of Congress
www.loc.gov/item/2011649140/
Plate 34 p. 97

"Speed! The Terror of the Sea," May 1, 1912
Puck, vol. 71, no. 1835 (cover)
Photomechanical offset color print
13.5 × 10.5 in. (34 × 27 cm)
Published by J. Ottmann Lith. Co., Puck Bldg., New York
Photograph retrieved from the Library of Congress
www.loc.gov/item/2011649142/
NSU Art Museum Fort Lauderdale; William Glackens Archives Collection GA.2024.15
Plate 35 p. 99

"He Had a Hunch," 1913
Cover for *Puck*, February 19, 1913
Commercial lithograph with hand-coloring
14.3 × 11.3 in. (36.2 × 28.7 cm)
Delaware Art Museum, gift of Helen Farr Sloan, 1978
Plate 38 p. 103

"When Duty Calls," September 24, 1913
Puck, vol. 74, no. 1908 (cover)
Photomechanical offset color print
13.5 × 10.5 in. (34 × 27 cm)
Published by J. Ottmann Lith. Co., Puck Bldg., New York
Photograph retrieved from the Library of Congress
www.loc.gov/item/2011649629
NSU Art Museum Fort Lauderdale; William Glackens Archives Collection GA.2024.16
Plate 40 p. 105

When Knights Were Bold, June 19, 1915
J. R. Bray Studios
Digitized 28 mm black-and-white silent film
9 minutes
The G. William Jones Film and Video Collection, Hamon Arts Library, Southern Methodist University
Figure 3.12 p. 41, plate 41 pp. 106–107

Untitled, c. 1915
Graphite on paper
10 × 8 in. (25.4 × 20 cm)
NSU Art Museum Fort Lauderdale; bequest of Ira D. Glackens, 91.40.276
Plate 51 p. 118

The Log of the Circumnavigators Club, 1917
vol. 6, no. 6 (cover)
Photomechanical offset color print in bound hardback
Richard Samuel West Collection
Figure 3.14 p. 42

Our Bone Relatives, April 1, 1918
J. R. Bray Studios
Digitized 28 mm black-and-white silent film
3 minutes, 6 seconds
George Eastman Museum
Figure 3.11 p. 40, plate 42 pp. 108–109

S.S. Adams Company, Asbury Park/
Neptune Township, NJ
Joy Hand Buzzer, c. 1928
Gift of the Friends of the New
Jersey State Museum, Cultural
History Contingency Fund
Courtesy of New Jersey State
Museum. CH2015.6.1
Plate 44 p. 111

*Untitled (Letter from "Uncle Lou" to
Lenna Glackens)*, December 6, 1929
Pen on paper
Three pages, framed, each sheet:
7 × 5.5 in. (17.7 × 13.9 cm)
NSU Art Museum Fort Lauderdale;
bequest of Ira D. Glackens,
ARC2021.990
Figure 3.9 p. 38

Louis M. Glackens
and William J. Glackens
Portrait of Lenna, c. 1930s
Oil on canvas
31.2 × 27.2 in. (79.4 × 69.2 cm)
NSU Art Museum Fort Lauderdale,
N.2015.4.20.4
Figure 3.10 p. 39

S.S. Adams Company, Asbury Park/
Neptune Township, NJ
Mustache, 1950s
Gift of the Friends of the New
Jersey State Museum, Cultural
History Contingency Fund
Courtesy of New Jersey State
Museum. CH2015.6.8
Figure 3.13 p. 42

S.S. Adams Company, Asbury Park/
Neptune Township, NJ
Black Widow Spider, c. 1950s
Gift of the Friends of the New
Jersey State Museum, Cultural
History Contingency Fund
Courtesy of New Jersey State
Museum. CH2015.6.4
Plate 43 p. 110

S.S. Adams Company, Asbury Park/
Neptune Township, NJ
Shooting Lip Stick, c. 1950s
Gift of the Friends of the New
Jersey State Museum, Cultural
History Contingency Fund
Courtesy of New Jersey State
Museum. CH2015.6.9
Plate 45 p. 111

S.S. Adams Company, Asbury Park/
Neptune Township, NJ
Smokie Cigarettes, c. 1950s
Gift of the Friends of the New
Jersey State Museum, Cultural
History Contingency Fund
Courtesy of New Jersey State
Museum. CH 2015.6.7
Plate 46 p. 111

S.S. Adams Company, Asbury Park/
Neptune Township, NJ
Dime Store Display Rack Sign,
c. 1957
Gift of the Friends of the New
Jersey State Museum, Cultural
History Contingency Fund
Courtesy of New Jersey State
Museum. CH2015.32.1
Plate 47 pp. 112–13

Untitled, n.d.
Graphite on paper
5 × 8 in. (12.7 × 20 cm)
NSU Art Museum Fort Lauderdale;
bequest of Ira D. Glackens,
91.40.280
Figure 3.7 p. 37

Untitled, n.d.
Graphite on paper
8 × 5 in. (20 × 12.7 cm)
NSU Art Museum Fort Lauderdale;
bequest of Ira D. Glackens,
91.40.281
Figure 3.8 p. 37

Untitled, n.d.
Graphite, colored pencil on paper
8 × 5 in. (20 × 12.7 cm)
NSU Art Museum Fort Lauderdale;
bequest of Ira D. Glackens,
91.40.229
Plate 1 p. 18

Untitled, n.d.
Graphite, colored pencil on paper
10 × 8 in. (25.4 × 20 cm)
NSU Art Museum Fort Lauderdale;
bequest of Ira D. Glackens,
91.40.272
Plate 2 p. 19

Untitled, n.d.
Graphite, colored pencil on paper
8 × 5 in. (20 × 12.7 cm)
NSU Art Museum Fort Lauderdale;
bequest of Ira D. Glackens,
91.40.244
Plate 3 p. 20

Untitled, n.d.
Graphite, colored pencil on paper
8 × 10 in. (20 × 25.4 cm)
NSU Art Museum Fort Lauderdale;
bequest of Ira D. Glackens,
91.40.273
Plate 4 p. 21

Untitled, n.d.
Graphite, colored pencil on paper
5 × 8 in. (12.7 × 20 cm)
NSU Art Museum Fort Lauderdale;
bequest of Ira D. Glackens,
91.40.241
Plate 5 p. 23

Untitled, n.d.
Graphite, colored pencil on paper
5 × 8 in. (12.7 × 20 cm)
NSU Art Museum Fort Lauderdale;
bequest of Ira D. Glackens,
91.40.285
Plate 6 p. 24

Untitled, n.d.
Graphite, colored pencil on paper
5 × 9 in. (12.7 × 22.8 cm)
NSU Art Museum Fort Lauderdale;
bequest of Ira D. Glackens,
91.40.292
Plate 7 p. 25

*Hurry up Girls—Here comes the
customers*, n.d.
Graphite on paper
17.2 × 21.3 in. (43.6 × 53.9 cm)
NSU Art Museum Fort Lauderdale;
bequest of Ira D. Glackens,
91.40.132
Plate 48 pp. 114–15

Untitled (double sided drawing),
n.d.
Graphite, colored pencil on paper
9 × 7 in. (22.8 × 17.7 cm)
NSU Art Museum Fort Lauderdale;
bequest of Ira D. Glackens,
91.40.269
Plate 49 p. 116

Untitled, n.d.
Graphite, colored pencil on paper
6 × 9 in. (15.2 × 22.8 cm)
NSU Art Museum Fort Lauderdale;
bequest of Ira D. Glackens,
91.40.283
Plate 50 p. 117

Untitled, n.d.
Graphite, colored pencil on paper
5 × 8 in. (12.7 × 20 cm)
NSU Art Museum Fort Lauderdale;
bequest of Ira D. Glackens,
91.40.265
Plate 52 p. 119

Untitled, n.d.
Graphite, colored pencil on paper
5 × 8 in. (12.7 × 20 cm)
NSU Art Museum Fort Lauderdale;
bequest of Ira D. Glackens,
91.40.228
Plate 53 p. 121

Untitled, n.d.
Graphite, colored pencil on paper
5 × 8 in. (12.7 × 20 cm)
NSU Art Museum Fort Lauderdale;
bequest of Ira D. Glackens,
91.40.255
Plate 54 p. 122

Untitled, n.d.
Graphite, colored pencil on paper
5 × 8 in. (12.7 × 20 cm)
NSU Art Museum Fort Lauderdale;
bequest of Ira D. Glackens,
91.40.230
Plate 55 p. 123

Untitled, n.d.
Graphite, colored pencil on paper
8 × 10 in. (20 × 25.4 cm)
NSU Art Museum Fort Lauderdale;
bequest of Ira D. Glackens,
91.40.274
Plate 56 p. 125

Untitled, n.d.
Graphite, colored pencil on paper
8 × 5 in. (20 × 12.7 cm)
NSU Art Museum Fort Lauderdale;
bequest of Ira D. Glackens,
91.40.262
Plate 57 p. 126

Untitled, n.d.
Graphite, colored pencil on paper
8 × 5 in. (20 × 12.7 cm)
NSU Art Museum Fort Lauderdale;
bequest of Ira D. Glackens,
91.40.289
Plate 58 p. 127

New Day, n.d.
Ink and blue pencil on paper
14.2 × 11.4 in. (36 × 29 cm)
Charles H. Kuhn Collection, The
Ohio State University Billy Ireland
Cartoon Library & Museum
Plate 61 p. 131

Untitled, n.d.
Graphite on paper
8 × 10 in. (20 × 25.4 cm)
NSU Art Museum Fort Lauderdale;
bequest of Ira D. Glackens,
91.40.249
Endpapers (front)

Untitled, n.d.
Graphite and pen on paper
15 ¼ × 17 in. (38.7 × 43.1cm)
NSU Art Museum Fort Lauderdale;
bequest of Ira D. Glackens,
91.40.275
Endpapers (back)

Untitled, n.d.
Graphite on paper
9 × 7 in. (22.8 × 17.7 cm)
NSU Art Museum Fort Lauderdale;
bequest of Ira D. Glackens,
91.40.231
Not reproduced

Untitled, n.d.
Graphite on paper
5 × 8 in. (12.7 × 20 cm)
NSU Art Museum Fort Lauderdale;
bequest of Ira D. Glackens,
91.40.239
Not reproduced

Untitled, n.d.
Graphite on paper
5 × 8 in. (12.7 × 20 cm)
NSU Art Museum Fort Lauderdale;
bequest of Ira D. Glackens,
91.40.240
Not reproduced

Untitled, n.d.
Graphite on paper
5 × 8 in. (12.7 × 20 cm)
NSU Art Museum Fort Lauderdale;
bequest of Ira D. Glackens,
91.40.252
Not reproduced

Untitled, n.d.
Graphite on paper
5 × 8 in. (12.7 × 20 cm)
NSU Art Museum Fort Lauderdale;
bequest of Ira D. Glackens,
91.40.253
Not reproduced

Untitled, n.d.
Graphite on paper
5 × 8 in. (12.7 × 20 cm)
NSU Art Museum Fort Lauderdale;
bequest of Ira D. Glackens,
91.40.260
Not reproduced

Untitled, n.d.
Graphite on paper
8 × 10 in. (20 × 25.4 cm)
NSU Art Museum Fort Lauderdale;
bequest of Ira D. Glackens,
91.40.271
Not reproduced

Untitled, n.d.
Graphite on paper
8 × 5 in. (20 × 12.7 cm)
NSU Art Museum Fort Lauderdale;
bequest of Ira D. Glackens,
91.40.298
Not reproduced

Untitled (A monkey painting, various other animals), n.d.
Graphite on paper
Object: 5 × 8 in. (12.7 × 20 cm)
NSU Art Museum Fort Lauderdale,
gift of the Sansom Foundation,
Inc., 92.91
Not reproduced

Additional Catalogue Illustrations

Edith Dimock Glackens
Trying on Room, Klein's, Union Square, n.d.
Watercolor on paper
10.8 × 15.5 in. (27.4 × 39.7 cm)
NSU Art Museum Fort Lauderdale; bequest of Ira D. Glackens, 91.40.75
Figure 2.2 p. 13

Lenna Glackens
Two Figures-Sphinx, 1922
Graphite and watercolor on two leaves of wove paper
7 × 4 in. (7.8 × 10.2 cm)
The Barnes Foundation, BF758
Figure 2.3 p. 14

Ludwig Bemelmans
Man and French Poodle on Couch, n.d.
Watercolor and ink on paper
3.3 × 5.3 in. (8.3 × 13.4 cm)
NSU Art Museum Fort Lauderdale, gift of the Sansom Foundation, Inc., 2020.10
Figure 2.4 p. 14

William J. Glackens
Christmas Shoppers, Madison Square, 1912
Conté crayon and watercolor on paper
16.8 × 31.9 in. (42.6 × 81 cm)
NSU Art Museum Fort Lauderdale; bequest of Ira D. Glackens, 91.40.106
Figure 2.5 p. 15

William J. Glackens
Patriots in the Making, 1907
Conté crayon and watercolor on paper
20.5 × 13.8 in. (52 × 35 cm)
NSU Art Museum Fort Lauderdale, gift of Patricia O'Donnell, 2017.7
Figure 2.6 p. 15

William J. Glackens
The Bandstand, 1919
Oil on canvas
24.3 × 29.3 in. (61.7 × 74.4 cm)
NSU Art Museum Fort Lauderdale, gift of the Sansom Foundation, Inc., 92.29
Figure 2.7 p. 16

William J. Glackens
Untitled, c. 1919
Charcoal and gouache on paper
4.9 × 6.8 in. (12.4 × 17.2 cm)
NSU Art Museum Fort Lauderdale; bequest of Ira D. Glackens, 91.40.47
Figure 2.8 p. 17

William J. Glackens
Sketchbook, c. 1919
Charcoal and graphite on paper
5 × 7.8 in. (12.7 × 19.8 cm)
NSU Art Museum Fort Lauderdale, gift of the Sansom Foundation, Inc., 92.68.27
Figure 2.9 p. 17

Photographer unknown
Portrait of Louis Glackens, December 1891
Cabinet card
Richard Samuel West Collection
Figure 3.1 p. 26

Puck magazine, first English edition
March 14, 1877, vol. 1, no. 1
Cover by Joseph Keppler
9 × 13 in. (22.8 × 30.4 cm)
Published by J. Ottmann Lith. Co., Puck Bldg., New York
https://www.loc.gov/item/sn77020423/
Photograph retrieved from the Library of Congress
Figure 3.3 p. 30

Puck Pavilion, reproduced in *Glimpses of the World's Fair: A Selection of Gems of the White City Seen Through a Camera*
Published by Laird & Lee, Chicago, 1893
Figure 3.4 p. 31

"I've Got a Permit," July 10, 1907
Puck, vol. 61, no. 1584
Photomechanical offset color print
13.5 × 10.5 in. (34 × 27 cm)
Published by J. Ottmann Lith. Co., Puck Bldg., New York
https://www.loc.gov/item/2011647218/
Photograph retrieved from the Library of Congress
Figure 3.5 p. 33

"The Latest in Easter Eggs," March 19, 1913
Puck, vol. 73, no. 1881 (cover)
Photomechanical offset color print
13.5 × 10.5 in. (34 × 27 cm)
Published by J. Ottmann Lith. Co., Puck Bldg., New York
Photograph retrieved from the Library of Congress
https://www.loc.gov/item/2011649478/
Figure 3.6 p. 36

Louis Glackens (bottom row, left) with the Circumnavigators Club, Place Viger Hotel, Montreal, May 19, 1907
Reproduced in *The Log*, July–August 1917
Published by J.H. Birch Jr.
Richard Samuel West Collection
Figure 3.15 p. 43

Puck's Quarterly, no. 35, October 1904
Photomechanical offset color print
13.5 × 10.5 in. (34 × 27 cm)
Richard Samuel West Collection
Figure 4.3 p. 50

Pickings from Puck, no. 57, September 1905
Photomechanical offset color print
13.5 × 10.5 in. (34 × 27 cm)
Richard Samuel West Collection
Figure 4.4 p. 50

"The Senate That Trusts Build," September 13, 1905
Puck, vol. 58, no. 1504 (back cover)
Lithograph on paper
13.5 × 10.5 in. (34 × 27 cm)
Published by J. Ottmann Lith. Co., Puck Bldg., New York
Richard Samuel West Collection
Figure 4.9 p. 54

"Back from Bololand," September 27, 1905
Puck, vol. 58, no. 1491 (cover)
Photomechanical offset color print
13.5 × 10.5 in. (34 × 27 cm)
Published by J. Ottmann Lith. Co., Puck Bldg., New York
Photograph retrieved from the Library of Congress
https://www.loc.gov/item/2011645739/
Figure 4.10 p. 54

"The Real Packingtown – If You Let the Packers Tell It," July 4, 1906
Puck, vol. 59, no. 1531 (centerfold)
Photomechanical offset color print
13.5 × 21 in. (34 × 53 cm)
Published by J. Ottmann Lith. Co., Puck Bldg., New York
Photograph retrieved from the Library of Congress
https://www.loc.gov/item/2011645916/
Figure 4.11 p. 55

"Theatre Designed for the 'Tired Business Man'"
Puck, vol. 75, no. 1940, May 9, 1914 (interior page)
Photomechanical offset print
13.5 × 10.5 in. (34 × 27 cm)
Richard Samuel West Collection
Figure 4.12 p. 56

"The Great American Traveler," September 25, 1907
Puck, vol. 62, no. 1595 (cover)
Photomechanical offset color print
10.5 × 13.5 in. (27 × 34 cm)
Published by J. Ottmann Lith. Co., Puck Bldg., New York
Photograph retrieved from the Library of Congress
https://www.loc.gov/item/2011647241/
Plate 10 pp. 60–61

"No More of That, Thank You. I'm Awake," March 24, 1909
Puck, vol. 65, no. 1673 (cover)
Photomechanical offset color print
Plate 14 p. 67

"In the Republican Dark-Room," March 2, 1910
Puck, vol. 67, no. 1722 (cover)
Photomechanical offset color print
13.5 × 10.5 in. (34 × 27 cm)
Published by J. Ottmann Lith. Co., Puck Bldg., New York
Photograph retrieved from the Library of Congress
www.loc.gov/item/2011647562/
Plate 21 p. 78

"The Heavenly Porter," May 18, 1910
Puck, vol. 67, no. 1733 (cover)
Photomechanical offset color print
13.5 × 10.5 in. (34 × 27 cm)
Published by J. Ottmann Lith. Co., Puck Bldg., New York
Photograph retrieved from the Library of Congress
https://www.loc.gov/item/2011647589/
Plate 22 p. 79

"Young America and the Moving-Picture Show," November 9, 1910
Puck, vol. 68, no. 1758 (cover)
Photomechanical offset color print
10.5 × 13.5 in. (27 × 34 cm)
Published by J. Ottmann Lith. Co., Puck Bldg., New York
Photograph retrieved from the Library of Congress
www.loc.gov/item/95508847/
Plate 25 pp. 84–85

"From Summer Boarders – Harvest Number," September 6, 1911
Puck, vol. 70, no. 1801 (cover)
Photomechanical offset color print
13.5 × 10.5 in. (34 × 27 cm)
Published by J. Ottmann Lith. Co., Puck Bldg., New York
Photograph retrieved from the Library of Congress
https://www.loc.gov/item/2011649059/
Plate 28 p. 89

"Look Who's Here!" December 27, 1911
Puck, vol. 70, no. 1817 (cover)
Photomechanical offset color print
Plate 31 p. 93

"Beg for It, Doggie!" March 13, 1912
Puck, vol. 71, no. 1828 (cover)
Photomechanical offset color print
13.5 × 10.5 in. (34 × 27 cm)
Published by J. Ottmann Lith. Co., Puck Bldg., New York
Photograph retrieved from the Library of Congress
www.loc.gov/item/2011649129/
Plate 33 p. 96

"He Doesn't Realize What is Coming to Him," July 17, 1912
Puck, vol. 71, no. 1846 (cover)
Photomechanical offset color print
13.5 × 10.5 in. (34 × 27 cm)
Published by J. Ottmann Lith. Co., Puck Bldg., New York
Photograph retrieved from the Library of Congress
www.loc.gov/item/2011649364/
Plate 36 p. 100

"La Première Danseuse," November 20, 1912
Puck, vol. 72, no. 1864 (cover)
Photomechanical offset color print
13.5 × 10.5 in. (34 × 27 cm)
Published by J. Ottmann Lith. Co., Puck Bldg., New York
Photograph retrieved from the Library of Congress
www.loc.gov/item/2011649401/
Plate 37 p. 101

"It Would be Worth It," August 20, 1913
Puck, vol. 74, no. 1903 (cover)
Photomechanical offset color print
13.5 × 10.5 in. (34 × 27 cm)
Published by J. Ottmann Lith. Co., Puck Bldg., New York
Photograph retrieved from the Library of Congress
www.loc.gov/item/2011649619/
Plate 39 p. 104

Cover
"The Invasion of England,"
August 18, 1909
Puck, vol. 66, no. 1694
(centerfold)
William Chrisant & Sons' Old Florida Book Shop, Fort Lauderdale
(Pl. 19)

Page 2
Louis M. Glackens
Untitled, n.d.
NSU Art Museum Fort Lauderdale; bequest of Ira D. Glackens
(Pl. 49)

Publishing Director
Pietro Della Lucia

Project Manager
Edoardo Ghizzoni

Art Director
Luigi Fiore

Design
Anna Cattaneo

Editorial Coordination
Emma Cavazzini

Copy Editing
Doriana Comerlati

Layout
Barbara Galotta

Photo Credits
Jim Gipe Photo / Pivot Media: fig. 3.1 p. 26, fig. 4.3 and 4.5 p. 50, fig. 4.9 p. 54, fig. 4.12 p. 56
David Guidi: fig. 3.3 p. 30, fig. 3.10 p. 39, fig. 3.13 p. 42, fig. 3.14 p. 42, pl. 8 p. 58, pl. 16 p. 70, pl. 17 p. 71, pl. 26 p. 87, pl. 27 p. 88, pl. 43 p. 110, pls. 44–46 p. 111, pl. 47 pp. 112–13, pl. 61 p. 131

First published in Italy in 2024 by
Skira editore S.p.A.
via Agnello 18
20121 Milano
Italy

In association with
NSU Art Museum Fort Lauderdale

© 2024 NSU Art Museum Fort Lauderdale
© 2024 Skira editore, Milan

All rights reserved under international copyright conventions. No part of this book may be reproduced or utilized in any form or by any means, electronic or mechanical, including photocopying, recording, or any information storage and retrieval system, without permission in writing from the publisher.

Printed and bound in Italy.
First edition

ISBN: 978-88-572-5328-2

Distributed in USA, Canada, Central & South America by ARTBOOK | D.A.P. 75 Broad Street Suite 630, New York, NY 10004, USA. Distributed elsewhere in the world by Thames and Hudson Ltd., 181A High Holborn, London WC1V 7QX, United Kingdom

skira-arte.com

NSU Art Museum Staff

Bonnie Clearwater,
Director and Chief Curator

Michael Belcon, The Wege Foundation Assistant Education Curator
Tina Benedictsson, Executive Assistant
Annette Cardoza, Business Administrator
Elisabeth de Lapresle-Wennberg, Major Gifts Officer
Smite Elize, Assistant Retail Operations Manager
Marivette Fournier, Events Manager
Sally Glenn, Retail Operations Manager
David Guidi, Communications & Public Relations Manager
Grace Harry, Donor Relations & Annual Fund Manager
Oliver Loaiza, Head Preparator
Caroline McNabb, Registrar
Margeaux Miller, Visitor Services Representative
Jordyn Newsome, Exhibition & Curatorial Project Manager
Karen Oleet, Assistant Director of Development
Danielle Phillips, Development Associate
Lisa Quinn, Lillian S. Wells Education Curator
Chip (Leonard) Rauch, Manager of Security
Marvin Rolle, Accountant
Marta Sidorek, Membership Associate
Tristen Trivett, Community Engagement & Arts Education Coordinator
Rebecca Vaughn, Senior Registrar
Cindy Jo White, Visitor Services Manager, Volunteer & Intern Coordinator
Ariella Wolens, Bryant-Taylor Curator

Board of Governors Directory 2024–2025

Officers

Michelle Howland Sussman, Chair
Andrew Heller, Vice Chair
Jake Wurzak, Vice Chair
Jeff Haines, Treasurer
Francie Bishop Good, Immediate Past Chair and Chair Emeritus
Stanley Goodman, At Large Member and Chair Emeritus
David Horvitz, At Large Member and Chair Emeritus
Laura Palmer, At Large Member

Scott R. Anagnoste
Sharon L. Berger
Francie Bishop Good
Holly Bodenweber
Frank Buscaglia, Esq.
Suzi Cordish
Jill R. Ginsberg
Stanley S. Goodman
Jeff Haines
Andrew Heller
Rita Holloway
David W. Horvitz
Michelle Howland Sussman
Gene Kaufman
Stephanie Krass
Whitney Lane
Per-Olof Loof
Alicia (Xiaoyi) Ma
Melissa MacNeil
Matthew Mandell
Linda Marks
Bailey Brooks Mashburn
Lanie Morgenstern
Cherilyn Murer
Tunde Ogunlana
Mildred Padow
Laura Palmer
Stephen B. Pierce
Susan Samrick
Barry J. Silverman
Laurie Silverman
Lisa Smith
Stephanie Toothaker, Esq.
Wayne P. Weiner
Jake Wurzak
Reggie Zachariah, Esq.

Ex Officio

Julie Deitchman
George Hanbury
Ann Harsh